Naive Painting

Phaidon 20th-century Art

With 72 Colour Plates by the following Artists

United States of America
Hicks
Barton
O'Brady
Hirschfield

England
Haddelsey

France
Rousseau
Bombois
Séraphine
Jean Eve
Dechelette
Schwartzenberg
Bauchant
Vieillard
Blondel
Fous
Bouquet
Barka
Vivin

Brazil
De Freitas
Morais

Yugoslavia
Generalič
Kovačič
Mehkek
Ilija
Lackovič
Skurjeni
Rabuzin

Czechoslovakia
Steberi
Rehak

Poland
Nikifor

Germany
Raffler
Dietrich
Thegen
Epple
Trillhaase
Ennulat
Grams
Odenthal
Dieckmann

Israel
Schalom de Safed
Messinger

Sweden
Bengtson
Hallström

Holland
Neervoort
Westbroek
Hagoort
Alexandrine

Switzerland
Lüthi

Austria
Dapra
Kratochwil

Belgium
Coulon
van den Driessche
Boyadjian

Italy
Benazzi
Toniato
de Angelis
Berganton
Ghizzardi
Prato
Verzelloni

Anatole Jakovsky

Naïve Painting

Phaidon · Oxford

Contents

Source of colour plates: National Gallery, Washington 33; Philadelphia Museum of Art, Philadelphia 34; Sidney Janis Gallery, New York 38; Jean Walter collection, Paris 40; Museum of Modern Art, New York 41; Narodni Gallery, Prague 42; Musee National d'Art Moderne, Paris 43; Private Collection, Paris 44; Narodne Gallery, Ljubljana, 56; Private Collection, Düsseldorf 57; Private Collection, Brussels 64; Clemens-Sels Museum, Neuss 65, 79, 81, 83, 94; Galarie Zimmer, Düsseldorf 66, 67, 70, 72, 74, 75, 80, 101; Rotterdamse Kunststichting, Rotterdam 82; Galerie Hamer, Amsterdam 103.

Translated by Ernest Torlesse

Phaidon Press Limited, Littlegate House, St Ebbe's Street, Oxford
Published in the United States of America by E. P. Dutton, New York
First published in Great Britain 1979
Originally published as *Naive Malerei*
© 1976 by Smeets Offset BV, Weert, The Netherlands
German text © 1976 by Verlag Herder KG, Freiburg im Breisgau
English translation © 1979 by Phaidon Press Limited
Illustrations © Beeldrecht, Amsterdam

ISBN 0 7148 1955 7
Library of Congress Catalog Card Number: 78–24649

Printed in The Netherlands by Smeets Offset BV, Weert

Naive Painting

If we want to approach the subject of naive painting with any degree of honesty, then we shall have to concede that nothing of what we know about the genesis of art in terms of the origins of an artistic movement can be likened to the adventure of naive painting. For this reason the present and rather recent popularity of naive painting appears to puzzle and confuse people, dividing the world into supporters and detractors. Very little of what has been written on the subject makes much sense; in fact, quite the reverse. Ill-judged comparisons of naive painting with drawings done by children or the mentally ill, with cave drawings, negro art or votive pictures, in short, with most forms of folk art, only contribute towards sustaining this confusion.

What is a naive painter?

A definition, admittedly, is not easy. While their work shows certain common features, there are other characteristics which are at variance with one another. Some elements seem to project beyond the purely naive, carrying the naive painter into the realm of high art. Thus the dividing line, though flexible, remains vague.

But, one may legitimately ask, surely other artists and artistic movements confront us with similar difficulties? Where does Impressionism end and Expressionism begin? Is it possible to draw a clear distinction between Analytical Cubism and Synthetic Cubism? The validity of such terms is not in question, but the problem remains.

Naive painting cannot escape this difficulty. Bearing this in mind we should approach the subject with due caution and avoid making snap judgements. Nevertheless, the following facts may serve as a useful start towards a definition of naive painting:

1. A naive painter is untutored and has invented his own expressive and stylistic alphabet entirely unaided. This does not, of course, imply that conversely a 'trained' painter can never be a Naive. There are 'professional' painters amongst the Naives, such as Marc Chagall, as well as bad painters, those who paint in a pseudonaive manner. The French refer to this latter category simply as *pompiers*. As can be appreciated, this fundamental difference separates the naive painters from all the representatives of folk art, even if only because the latter work according to certain rules and patterns which have been passed down through the centuries from one generation to another, usually from father to son.

2. Every truly naive painter has his own vision of the world which, in some mysterious way, is uniquely different from that of any other. What do Rousseau and Séraphine, Adalbert Trillhaase and O'Brady, Morais and Lüthi have in common? This is why naive art is not something that can be taught, and any attempt to imitate it will be as spurious

as a copy of an abstract picture by Kandinsky. For the same reason there can never be a School of Naive Painting, which means that the famous 'École de Hlebine' is a contradiction in terms.

The individual vision of every naive painter arises from a condition of the soul, which is particularly unique and commanding. This vision, like every artistic concept, merges with a necessity to express itself, a necessity much stronger than the artist himself. He succumbs to this necessity and is forced to realise his vision at all costs. One is reminded of what 'le Douanier' Rousseau said: 'It is not I that am drawing, it is this thing at the end of my hand.' The conclusion to be drawn from this is that the naive painter is akin to a person possessed. He is in the grip of a 'thing', the nature of which he cannot 'logically' understand.

3. Finally, what is of cardinal importance is that the naive painter should be blessed with the gift of talent, and not paint merely for the fun of it or to pass the time, as a kind of week-end hobby. Otherwise he will be no different from any number of charlatans and bunglers who try their hand at painting. Thus naive painting, in comparison with what might be called main stream painting, is not to be seen in terms of its 'importance' but in terms of its visionary quality. Naive pictures exhibiting no real qualities, or which draw upon the tradition of art of all ages, styles and schools can, at best, remain curiosities. They represent forms of expression on a level with so many others which are prone to crude utterances of joy or the cries of sick, mutilated and mortally wounded souls. As such they belong to 'art brut' where, strictly speaking, it has become unnecessary to insist upon the word 'art'. Alternatively, naive pictures are like trifles produced by children playing with forms and colours as they would with dolls and toy bricks. Of course, this does not mean that one should equate naive painting with paintings done by children.

4. Not everyone who wants to be can be a naive painter, a truism worth repeating yet again.

What long ago was seen as clumsy, awkward and lacking any painterly skills nevertheless demonstrates an arrangement as orderly and coherent as that of any other kind of painting. Its rhythms are consistent, its colours harmonize — only differently, that is all. The archaic, old-fashioned look of naive painting doubtless goes back to the archetypes discovered by the famous Zurich psychoanalyst Carl Jung; one might say that naive painters have certain pictorial ideas circulating in their subconscious which, quite spontaneously, demand to be given release. Their pictures seem to begin like an old fairy tale, 'Once upon a time . . .'.

Thus naive painting is neither of yesterday nor of today, but timeless. Perhaps of tomorrow, who knows. One might put it aptly by saying that the Naives are for ever in search of a 'paradise lost' and that their paintings are a transfiguration of all those things life has robbed and cheated them of, a creation of 'paradise regained'.

5. Even if, in essence, all naive painting is the same, the roads leading there are very diverse. Certain quite distinct things have to happen to give these pictures their particular and recognisable quality.

The effect of the climate and soil, the degree of familiarity with the technicalities of painting, the presence or absence of an old folk culture together with certain intangible

elements, the air, the time, mysterious feeling for colour, all these combine to make an indelible impression upon the artist. Consequently French naive painters are different from those in America, and those in America differ from those in Germany. The differences are as easy to spot as those that exist between the popular art of central Europe and that of South America.

Early painting in the United States

As a rule naive painting makes its appearance at the very moment that folk art disappears. This occurs everywhere where the craftsmanship involved in the making of a product gives way to industrial methods of production and instead of following a prescribed way, man ventures forth into the unknown. Thus, paradoxically, the youngest of the great nations also has the longest history of naive painting, a fact easy enough to explain. The nations and races which were thrown into the melting pot to make 'America' lost all memory of the traditions of their folk art. To this absence of folklore must be added the absence of any kind of basic artistic education. These are all important factors, indeed, the only factors which allow naive art to blossom, if not to unfold and develop. Where else would one find such favourable, not to say ideal ground for the growth of naive painting, than in this immense virgin territory, crossed by endless wagon trains, pushing the frontier ever further West and bringing with them new laws; a country of fragile wooden towns with small artisan businesses, of big ranches taking in the savannah and the forests. Naive painting can show all the strangeness of this new world; it owes no debts to the present or the past. Thus it can improvise freely, following its own possibilities, unfettered by any tradition. It is not surprising, therefore, that in America naive painting made its first appearance as early as the end of the seventeenth century. The earliest pictures are portraits depicting, of course, the pioneers, men and women who, for some reason, wanted to pass their image on to posterity. Most of these pictures are anonymous, or signed with the names of people about whom little or nothing is known. Evidently they are a manifestation of that ancient, incurable and quite universal desire for immortality, which is a hidden source of all art. Ever since the dawn of history, when he experienced his first orgasm and dwelt in caves, and clothed himself in animal skins, man has had a revelation, an awareness of death. Animals know neither the one nor the other.

André Malraux, a man one may love or hate and whose opinions one may or may not share, was one of the first to recognise the legitimacy of naive painting. 'It is an act which the indifference of the heavenly constellations and the eternal rushing of the rivers are powerless to affect; it is an act of redemption in the face of death.'

The pioneers of the Wild West confirm this rule in their portraits. These fine men and 'grass capitalists' had their merits as well as their patents of nobility, not gained by divine right, but by the simple right of what one could take and keep, if necessary with the aid of a Winchester and a saddled horse. Had they not been so proud of their achievements, their thoughts might never have turned to painting. The churches, filled largely with protestant pioneers, needed no paintings, and the puritanism of the

first settlers, their unquestioning virtuousness, would have made them distrust pictures as a form of papist luxury. But a portrait was somehow different.

In Europe one would have commissioned a well-known portrait painter, someone who had studied painting from an early age. But in a pioneering country this was impossible. One just had to be satisfied with the efforts of 'limners', as they were nicknamed, dabblers and amateurs, who certainly had talent but were untaught and simply did the best they could. Their crude, painterly exertions resulted in works of remarkable accuracy. They moved from ranch to ranch, from farm to farm and from town to town, much as the travelling photographers did later. After the invention of the daguerrotype, incidentally, many of them adopted this new method of recording reality. In fact, many of them had already long before taken refuge in the 'camera obscura'. The ease with which these travelling painters changed their trade, perhaps starting their career as ordinary painters and decorators, before moving on to photography via portraiture, even if only because photography was quicker and therefore more profitable, shows the absence of any artistic pretentions. It exposes the integrity of the honest worker. The more these painters put into their portraits, the more they charged. There was a sliding scale of fees, depending on the likeness of the portrait with the model, whether it made use of light and shade, in other words whether it employed chiaroscuro. On the reverse side of one of these portraits, executed by a man called W. H. Prior, is written: 'Portrait painted in this style — done in about two hours — price 2.92 Dollars, including frame and glass.'

However, one should not be led into believing that this particular method of painting was only practised on the other side of the Atlantic. By no means! Some modern Naives have worked in a similar manner. Micheline Boyadjian, a painter from Belgium, for many years kept a book in which she recorded the number of hours spent on a portrait. For reasons not absolutely clear, she employed as a unit of account the hourly rate paid to a lead founder. Demonchy, on the other hand, an employee of the French railways, who at a certain stage specialised in funeral pictures, painted so called first class and second class pictures. Depending on the number of little people placed behind the hearse, he charged a single or a double rate, according to what the customer could afford to pay.

Some of these travelling painters, in order to be able to work even quicker, prepared their canvasses in advance. They painted in the background and various ornamental detail, into which would then be placed the figures of the men and women in their Sunday finery, with a choice between a sitting and a standing pose. Only the space for the head was left blank, which was then painted in in the presence of the model. This working method also reminds one of the usual procedure adopted by travelling photographers, who made their money from so called souvenir portraits. They either worked at fairs or garrison towns, and used all sorts of dummies and cut-outs to represent the uniformed torsos of soldiers belonging to different service branches, infantry, artillery or cavalry. The head of the photographed model was then simply stuck on to the ready made photograph.

One thing seems certain. The desire to leave behind some trace of one's earthly existence, the thirst for immortality, must have been very strong, judging by the

impressively large number of portraits which have survived. It is this desire for 'survival' which has given us such an incomparable gallery of austere judges, chubby cheeked babies, frigid mothers, fearless riders and robust old men. They look as if they were made to illustrate a saga by William Faulkner. These largely anonymous portrait painters are the Clouets, Fouquets, Holbeins, Reynolds' and Gainsboroughs of the New World. Such a comparison is perfectly justified, for there were no other painters to be found in this pioneering land.

A notable example of such heads drawn very much to type are the striking pencil portraits executed almost a century later by Gertrude O'Brady, the best naive painter after 'le Douanier' Rousseau. Caught unawares by the entry of the United States into the Second World War while living in Paris, she was interned in the Vittel concentration camp. Deprived of paint, she made extensive use of her pencil, drawing her American and English fellow prisoners quite independently of their social status: parsons, jockeys, bankers, chamber maids and society ladies. Gertrude O'Brady has surpassed herself in these works, and circumstances really do allow a comparison with Clouet as well as with Cranach.

But to come back again to the travelling portrait painters in America. Very occasionally one comes across a painter who, blessed with a clear vision of that 'other' nature, is struck by the beauty of a meandering river, a rushing waterfall, the endless plains and snow-covered hills, the bringing in of the harvest or a scattering of chicken in a farmyard. Or another, who has recorded an old spinster arranging fruit on an embroidered tablecloth with meticulous precision, or gracefully counting each individual hair on the head of her favourite cat.

Many other painters depict family gatherings, festivals, burials, street scenes and boxing matches. Ultimately all these artists left behind them the rather ambiguous trade of portrait painting to join the great body of naive painting. These are the painters who begin to show a certain degree of individualism and independence similar to other artists.

The discovery of this independent American style is still relatively recent. Up to the years preceding the last war the Americans had completely ignored it. It was only after the arrival in New York of a French touring exhibition called 'Popular Masters of Realism', that their eyes were opened to these 'primitives'. In America one spoke of 'early painting', in order to avoid using the word 'naive'. Since this event, these pictures have been widely sought after, so that very few of them are now left. They are all in museums and important private collections.

What distinguishes American naive painting from French naive painting is the manner in which a particular every day occurrence is shown; the approach of the Americans is neat, positive, documentary and somewhat photographic. The pictorial subject is narrowly circumscribed and treated with a certain severity and bluntness of manner. The look on many of the people's faces is cold without warmth or emotion, like the cheeky inquisitiveness of a youth who has not yet known sex or desire. It is a look of vague surprise that things are as they are, and that the world is as it is. Is this to be put down to the influence of protestantism, or is it due to the social status of these painters, so different from that of their French colleagues? It is impossible to say. Nevertheless, this is a persistent feature of all figurative painting in America, be it

naive or otherwise, starting with the 'realists' right through to the present-day 'hyperrealist' school.

In France it was Jean Eve who more than any other painter demonstrated this cautious, cool approach to the visible world. His creative life was unfortunately cut short by an early death. He was one of the great representatives of this type of painting, although the inheritor of a certain kind of tradition. Some of the blood of Courbet coursed through his veins. He was familiar with examples of his work, and absorbed much without being aware of it. The question of whether or not this is still naive painting is irrelevant. Nevertheless, Jean Eve is a Naive. This is shown by his hidden emotion and sincere identification with the subject matter of the paintings, mainly landscapes. Jean Eve always painted directly from nature, unlike the great majority of naive painters who worked at home and from memory — which accounts for the small imperfections of their pictures based as they are on a lack of knowledge and experience, a defect which the professional painter would inherit from his academic training. René Rimbert, another painter of spacious landscapes, is also an exception, in that he too always painted straight from nature.

The lyricism of French naive painting

It is quite obvious that French naive painters, be they good or bad, have more warmth, more lyricism, much more inventiveness and imagination. It could hardly be any different, because for them painting was never a trade carried out to make money. At least, this was the case until the first quarter of the twentieth century. For them painting was an escape from the unbearable drudgery of the working week, a state of ecstasy into which they could retreat during precious weekends and holidays. They were like freebooters, anarchists, mystery-mongers, a condemned and cursed race of people, in short, painters who only painted for pleasure. They painted without the slightest hope of exhibiting, of getting commissions, or being able to sell their work. They painted from inner necessity, unlike the Americans, whose work was useful and necessary, like carpentry and bricklaying, and was remunerated accordingly. Their passion for painting stemmed from an uncontrollable impulse. Their 'hobby' was an opiate, a drug which allowed them to endure a life they could only accept with reluctance.

The arrival of the industrial revolution finally extinguished all traces of the older forms of life, and one after another, the naive painters of America disappeared, swept away by a new type of folklore, this time the urban one of Pop Art. France, a technologically advanced country with a slower and more harmonious evolution (a fact already pointed out by Karl Marx) took longer to succumb to this process. Eventually France too gave in to the brutality of the 'American way of life', to become another modern consumer society. Thus France, as if nothing had happened, and over a fairly long period of time, continued to produce wave upon wave of naive artists who were as active and who produced work as varied as those of the previous century. This 'delayed' development is the external reason why France occupies one of the most important positions in naive painting, both in terms of quantity and quality. The more

immediate reason is to be found in the convulsions and consequent social uprooting, attended by a spiritual crisis and a general climate of unease, which gradually affected all levels of society. For this reason young and old, rich and poor, men and women, turned to naive painting as an antidote. I shall take up this point again later.

The first naive painters appeared in France towards the end of the eighteenth century, exactly one hundred years after America. They are a direct as well as an indirect result of the French Revolution, a Revolution which really represented a social as well as a cultural turning point. Nothing could ever be the same again, especially in the areas of thought, feeling and action. The whole concept of originality was redefined. Men and women could no longer love and dream in the same way as they had done before the Revolution.

'Europe has a new concept of happiness' said Antoine Saint-Just (1767–1794), a writer and politician who stood on the frontier between two worlds, the end of feudalism and the beginning of that capitalism which led to the modern age and in which, whether we like it or not, we have the good or the bad fortune to live, squeezed between the last remnants of the Middle Ages and the pale dawn of a new era. Happiness, correctly speaking, is the inalienable right of every individual to assert his own individuality, a right which in former times was only accorded to the privileged few. Isidore Ducasse, the Count of Lautréamont, that gloomy figure, expressed the same idea when he said that everybody and anybody could be a poet. 'Poetry must be written by everybody and not just by poor Hugo, poor Racine, poor Corneille, poor Boileau!' It is easy to see how the Surrealists could turn such a controversial statement to their own advantage.

If one applies this new liberty to painting, it is easy to see that at some time somebody would come along who would not shrink from exhibiting almost anything. Inasfar as painting mirrored the visible, real world it passed from negation to negation to become distorted out of all recognition. The 'picture' became a mere matter. Worse still, the artist became a kind of robot taking little creative part in either conceiving or creating 'his' work.

The circumstances of the time forced the French Naives to take upon themselves this right to paint, in almost the same way as the American Naives had before them. The reason for this lies in the fact that the French Revolution removed the guilds, thus robbing painters of all teaching and instruction, however elementary this may have been. Up to then anybody with any degree of talent, anyone who at an early age showed any skill for, say, modelling, tailoring or drawing, took up an apprenticeship at one of the numerous guilds. These guilds existed to carry on the tradition of a certain craft, and after the completion of his apprenticeship the craftsman could practice his particular craft for the rest of his life. He might be a picture dealer, dominoe cutter, cabinet maker, wrought iron worker, bookbinder, sculptor, gilder, decorator and so on. His feeling for beauty could fulfil itself in these activities, accompanied by an honest love for a well made piece of work. These craftsmen were unencumbered by any complexes, producing a multitude of faultlessly worked pieces, half work of art, half common utensil. Some of them became painters, sometimes even very great painters, like J. B. Chardin, for instance, who was the son of a joiner from the Paris left bank.

Folk art and naive painting

Those who were less talented devoted themselves to folk art, the art made by the people for the people and for a long time only accessible to the people. Its echoes may be found in Latin America, though here too it will soon disappear in the face of advancing and more profitable mechanical processes. For twenty years now an irreversible process of degeneration has been taking place. Since folk art no longer meets the genuine needs of the people, it has to be content with supplying street traders with baubles to meet the tourist's appetite for exotic things, be they well or badly made. In France and in the whole of the western world folk art completely disappeared with the last painters of votive pictures; an exception perhaps are the *Santonniers* in the Provence who, like their Brazilian, Mexican, and Guatemalan counterparts, are, regrettably, on the decline.

Guillaume Apollinaire, who had a special love for votive pictures, said of the paintings in Notre Dame de Laghet: 'The very meticulous clumsiness of primitive art which is evident here has a certain something which impresses even non-believers. There are paintings of every kind and individual portraits are hardly ever to be met with. All contributions are exhibited for ever. It is enough for art to be a reminder of a miracle which took place because of the intercession of Our Lady of Laghet.

Every conceivable misadventure, fatal illness, deep pain, the whole of human misery is caught in the naive, reverent and unaffected style. The raging ocean is tossing a pathetic, helpless nutshell back and forth, in which a man kneels, bigger than the ship itself. All seems lost, but the Virgin of Laghet is watching over him in a bright halo from the corner of the picture, and so a devout person is saved. An Italian inscription confirms this. That was in 1810 . . . A carriage, pulled along by unmanageable horses, is careering towards an abyss. The travellers will be hurled onto the rocks below and perish. Mary watches over them from a bright halo in the corner of the picture. She had placed bushes along the edge of the abyss. The travellers clung to these and were saved, and afterwards gave this picture to the monastery of Laghet to commemorate the event. That was in 1830 . . . And so it continues, 1850, 1860, every year, every month, almost every day the blind are enabled to see and the dumb enabled to talk and the consumptive lived, thanks to the Madonna of Laghet, who smiles gently from the corner of the picture surrounded by a yellow halo' (G. Apollinaire, *L'Hérésiarque et Cie*, Paris 1910).

One may think of these painters as naive painters but this is not so in a true sense, even if only because, instead of creating new works, they in fact repeated a number of situations which they had learnt by heart. Whether the year is 1810, 1830, 1850 or 1860, one has the impression that these pictures are all painted by the same person. The inner spirit, the landscape, and the people are stereotyped. The same applies to the arrangement of the colours. One feels that these miracles, exciting though they are, have not moved the person commissioned to paint them.

The truly naive painters must be sought for elsewhere. They had an obsessive memory for the smallest detail which, as soon as they were able to escape from the mines and factories at the end of the day, they committed to canvas. Their studios

were like chapels in which they made their most secret confessions. Here they gave body to their dreams, lived their fantasies, created a 'reality' which was denied them in real life. But the circumstances of the next few years only hastened their decline as more and more family businesses closed to be replaced by a more relentless factory system. Thus, by the end of the nineteenth century nothing was left. Folk art was finished. But while 'nature contracted under the searing breath of the smelting furnaces', as expressed rather beautifully by Baudelaire, naive painters became more numerous than ever.

The various reasons for the emergence of naive painting

In 1972 George Schmits, a young Belgian student, chose this subject to write a thesis on, for which he gained a 'distinction'. In it he gives a graphic illustration of how industrial expansion exactly matched the growth of naive painting. The development could hardly be shown more clearly.

Halfway through the middle of the nineteenth century, the bitterness felt towards the process of industrial expansion, with its inevitable material and spiritual experiences, reached a climax. An intense reaction set in and remedies were sought and applied. 'Le facteur' Cheval was born in 1836; Abbé Fouré in 1842 and 'le Douanier' Rousseau in 1844. These are the three giants of, for want of a better description, naive painting.

It was the springtide of autodidacticism: painters, sculptors, inventors, poets, writers, philosophers, spiritualists, illuminists, revolutionaries, magicians and peddlars of panaceas, a whole body of people shouted their anger and suffering at the world or sang songs about their illusions and chimerical fancies. They worked under the most difficult material circumstances, denied themselves all rest, sacrificed their health which was always in a poor state, and squandered the little money they could have put aside for their old age on painting, without any hope of being able to make good their losses through the sale of their work. Employers did not pay pensions and there was no state-supported old age pension scheme. It was march or die! Many of them ended in asylums and their work landed on some anonymous street market.

What is known of an artist called Denimal, twenty of whose remarkable paintings one day appeared scattered over the market at Bicêtre? Who has heard of Guiraud de Saint-Chignian, who was born in 1892 in the Hérault, whose pictures were of even more remarkable quality and so perfect, that unsuspecting Rousseau specialists attributed his *Earthly Paradise* to Rousseau, even though the picture had been properly signed and showed no features which would suggest such an attribution?

Many, far too many pictures were destroyed or simply vanished without trace, due to lack of interest shown by the painters' contemporaries. The fact that between the First and Second World War tens of thousands of these paintings appeared in every street market in France had not the slightest effect. A lack of foresight, combined with the inadequate funds of the Musée des Arts et des Traditions Populaires, which was founded in Paris in 1936, allowed these pictures to disappear. Once the museum started to look for them again, it was too late. Most had gone to America, following the

discovery there of their own naive artists. A few of them finally ended up as Rousseaus, which only goes to prove, yet again, that there was naive painting before Rousseau, as there will be after Rousseau, and that he was by no means its only inspirational force. Calculating critics and dealers wanted at all cost to keep him separate from other naive painters. He was doubtless the greatest but not the only one. He is a symbol comparable perhaps with the tomb of the unknown soldier, honoured in the name of millions of soldiers who died on the field of battle and who have no burial place. To this must be added the many fakes. The signature on a picture by, say, Dupont or Durant was scraped off and substituted with that of Rousseau. Usually the substitution is badly executed, another proof of the fact that the quality of the faked picture was as good as that of a Rousseau. Obviously these are not deliberately manufactured fakes, but genuine paintings of the same period, which accounts for their change of identity.

Even though the first industrial revolution happened in England and only belatedly spread to France, France must be accorded the distinction of having speculated more than any other country about the world and man's place in it, and of having translated this speculation into forms of expression, not only in literature but also in the fine arts.

If one studies the little pink and blue lithographs made in the first quarter of the nineteenth century, postcards showing views of London and Paris, one is aware of an extraordinary difference. While London, seen from Blackfriars Bridge, is already bristling with factory chimneys, suggesting a steady drizzle of soot which was soon to cause that notorious phenomenon known as smog, the streets of Paris, in contrast, still look countryfied, there are no pavements, the roads are not asphalted and bushy trees are abundantly in evidence, waiting for the sunny, confetti-like canvases of the Impressionists.

The literary reactions to this first industrial revolution are interesting and reveal the characteristic difference between the English and French mentality. In England the novels of Walter Scott release a wave of romantic nostalgia for the middle ages, which were seen as at once heroic and dark. Horace Walpole's *Castle of Otranto*, published in 1764, heralded the beginnings of this new mood which soon spread over the whole of Europe. Mention should also be made of the *Poems of Ossian*, much loved by Napoleon and Goethe, who quoted some of them in his youthful work *Die Leiden des Jungen Werther*. These so called *Poems of Ossian* were forgeries composed by a certain Macpherson (1736–96), and represent an appeal to an even more distant past. England was gripped by a Gothic mood, evidenced even in its most utilitarian pieces of architecture. But in France Rousseau was extolling the virtues of country life as opposed to life in the city. Bernardin de Saint-Pierre wrote *Paul and Virginia*, an outstanding naive novel, which Lamartine described as a 'handbook of naive love'; and Stendhal wrote in his diary on the 16th Messidor of the year XI (July 5, 1804), 'naiveness seems to me to be the sublime element of ordinary life'. There is a firm belief in the 'goodness of unfettered nature', and everywhere botanical gardens seem to appear as a first step towards the preservation of nature. The ardent offender and, in his last years, prophet of the consumer society, the famous Marshall McLuhan, was under no illusion when he said: 'The new machine-orientated environment has turned the old environment into a work of art. The machine has transformed nature into an art form. Now for

14

the first time men have begun to see nature as a source of aesthetic and spiritual values. Men have begun to wonder why previous epochs did not perceive the totality of nature as art'. One might be tempted to see this as a call in favour of 'Land Art' which, together with 'Body Art', has for some time been exploring the external design of the natural landscape and the physical mysteries of the human body, instead of providing substitutions, whatever form this substitution may take.

Around 1785, in the meantime, there was published simultaneously in Paris and Amsterdam a collection of fairy stories which contained popular tales drawn from all ages and all countries and also included some tales from *A Thousand and One Nights*. These had been translated from Arabic by Antoine Galland, at one time a secretary in the French embassy in Constantinople, and were published in Paris, their first appearance in Europe, for his widow Claude Barbou. The success of this collection was instantaneous and exceeded the most extravagant expectations. Originally conceived in thirty volumes, to be published at the rate of two per month, the edition finally went into forty-one volumes. The last two appeared in the first half of 1789, the year which saw the fall of the Bastille.

But an event even more remarkable and important was the publication of another work during the same period, between 1787 and 1789, entitled *Voyages Imaginaires, Romanesques, Merveilleux* — in thirty six volumes. It formed the perfect adjunct to the fairy tale collection of 1785 and it arguably represents the first true collection of stories belonging to a genre now termed 'Science Fiction'. The century had broken loose from its familiar moorings and was anchoring along foreign shores. From the secrets of the past to the mysteries of the future, the circle had closed.

Simultaneously the brothers Wilhelm (1786–1859) and Jacob (1785–1863) Grimm were collecting popular German fairy tales with equal dedication and success. The anonymous author of the introduction to the 1785 collection of fairy tales was right when he said: 'The naive and familiar tone, the genial manner, the simplicity which inhabits these stories are such as to ensure the success they enjoy; who can tell whether as many stories from our own time, written with a claim to higher pretensions and in a more polished and lofty style, will enjoy the same success.' This might have been written in our own time by some honest and clairvoyant art critic in relation to an exhibition of naive painting.

These literary events at least created an intellectual climate in which naive painting could flourish, though it was sorely tested in England by the interference into people's lives due to the spread of the machine age. The peculiar cultural climate of France allowed French painters to express ideas in their work which English painters, reeling under the shock, did not even have time to think of.

English naive painting, which had been practically non-existent during the rise and prosperity of the Empire, only now began to develop, mainly amongst the disappointed and insecure lower middle classes, and especially amongst old and very 'Victorian' ladies. The Second World War, which had no losers and no victors, has dealt a mortal blow to an age nurtured by the idea of progress, and at last England, too, has become a country in which naive painting can flourish.

The 'development' of naive painting

Having given a brief account of the origins of naive painting, I shall now deal with the various phases of its development or, to put it another way: how did naive painting manage to become accepted and as important as any other type of painting, whether realistic or abstract.

At first glance the word 'development' hardly seems to be appropriate. Various ways of seeing and of transmitting what is seen arise, develop and, after a certain period fade away. This simple process embraces every conceivable permutation of change and implies a desire, indeed an obligation, to give visible expression to such permutations. It also implies an obligation to define man's place in the Universe and, even more, an obligation to place man, both physically and spiritually in the context of a living world which is recognisably his own.

The philosopher Oswald Spengler rightly or wrongly built his whole theory of the 'decline of the west' on this idea, using as a metaphor the four seasons of life. Thus the early Christian symbol of the fish, a symbol of magic as well as of a very realistic faith, reappears as a fish bone on a plate in a picture by Braque, before which it has passed through every conceivable representational stage. It has charted the progress of our pain. Thus the quest for a photographic mirror of the visible world, a process which has been going on for about two thousand years, ends in the pictorial representation of its skeleton or rather of its bleached bones. Dust to dust, ashes to ashes . . .

The Cubists' attempt to question everything, to analyse it, to disassemble it piece by piece in order to reveal the secret of its existence signifies nothing more than this.

The consequences are only too familiar. A kind of dialectical process is sought, whereby all things which have become exhausted and devitalised — the ashes of past events — are transformed at a certain moment into different elements. At this point it is no longer the meaning of these elements which is important but their last residue, their forms and colours, inert naked matter, without any meaning within a defined, concentrated order. This is the source of abstract painting, the intermediate stage of being nothing and saying nothing which is reduced to a simple, unconditional rejection of reality, just as the confetti of sunlight which Claude Monet spread over his canvasses were moving slowly in the direction of 'tachistic' painting.

At one time, and not that long ago, it was customary to turn to the wall all the mirrors in a house in which somebody had just died, or a picture was covered with mourning crêpe. This was done because a world had ceased to exist and it was believed that by blacking out its reflection one could bury it. Our neolithic ancestors did something similar when they shot arrows at a picture of the animal they were hunting in order to place it at their mercy. Perhaps the famous black square on a white background by Malevich also owes its existence to this kind of notion.

But this of course is not the world the Naives move in.

Naive painters whether of the eighteenth century or the present day continued or continue to paint 'naively', as if nothing ever changed. They are painting in the same way now as they have always done. Times, events, alterations in fashion and taste

seem to leave them unaffected. Governments might change, horsepower might be replaced by motorised car and men might land on the moon, but their vision and, even more their pictorial language remains completely unaltered. They never knew the Impressionists, Van Gogh and Cézanne, nor were they acquainted with the Cubists, the Surrealists or Abstract Painting. While other painters were in the grip of an artistic development which not only made their own pictures seem insignificant but even called in question the worth of easel painting itself, the Naives, in contrast, clung more than ever to the concept of the picture, as if they wanted to preserve this reflection of the visible world, this magic mirror held up to nature. Painting has never been anything else but this. Naturally, naive painters were not doing this consciously.

The Naives continued with their monologue and persisted in keeping a diary into which they unburdened themselves, quite outside any kind of historical frame of reference. They rejected the idea that their work should in any way be 'contemporary'.

Due to the absence of any written evidence very little is known of their early history, which comes to an end around 1885–86, about the time that Rousseau was beginning to attract the interest of the public. The press, at that time, completely ignored them. All we have are a quantity of paintings which can be only partially dated, because, as a rule, they are neither dated nor signed. Stylistically they vary little and only secondary features, such as the surrounding view or the clothes and costumes worn by the figures, allow one to assign them to a certain period. But even this evidence is not always conclusive. Many Naives paint imaginary landscapes and show a special liking for the past. They do not always paint what they actually see.

The paintings of Gertrude O'Brady, depicting the streets and shops around the turn of the century, seem to recall the golden days of the 'Belle Époque', and yet they were painted between 1939 and 1942. The anachronism of naive painting, the absence of any contemporary reference, deliberate or not, is something one finds in other archaic means of expression, especially in folklore, where features peculiar to the medieval period persist into the nineteenth century.

Le Douanier Rousseau: a conflict of opinion

One should not be led into believing that the history of naive painting actually begins with the arrival of Rousseau. Its beginnings should be placed in some mythical period, a land of anecdote, where fiction is more important than fact. If only people had taken Rousseau or his painting seriously. But it was still much too early.

To get some idea of this state of affairs it is enough to look at the occasional mention which Rousseau was getting in the press by journalists and art critics after he first exhibited at the Salon des Indépendants. He was teased, ridiculed, even insulted, and poor Rousseau, who regularly read the *Argus de la Presse*, pasted any article mentioning his name into an exercise book specially purchased for this purpose. One finds not a glimmer of understanding, but only a unanimous chorus of disapproval. What an extraordinary belief he must have had in his own work, what courage must have sustained him in order to continue to paint under such conditions.

This was the only Salon that would exhibit his work, a veritable refuge for all

those whom luck had deserted. There was no jury, and therefore everything was accepted. Rousseau's pictures would never have got past a jury of professional painters. As for showing his work in one of the few galleries in Paris — it was unthinkable. Thus the first one-man show of his work took place after his death.

Gustave Courbet, writing of the Salon des Indépendants, said: 'The laughter which Rousseau's paintings provoked is still ringing in my ears. They were well hidden, of course, the hanging committee had banished them into dark corners on the fringe of the exhibition; they were more or less inaccessible, due to the pools of water which had been ingeniously spread over the ground. But of course they were found by a few wags and buffoons, people who knead the spiritual bread for every exhibition, and when their search was finally rewarded the barrack-like exhibition building was shaken with the explosions of their laughter' (Les Indépendants [1886–1920], Paris 1921).

L. Roger-Miles, another fairly well known critic, asked quite bluntly: 'What can one say about the portraits by Mme Ernesta Urban and the enigma of this painter? I saw nothing remarkable apart from the Suicide and the pictures by Mr Rousseau, and the Nuit Étoilée by Mr van Gogh, with the admitted difference of course, that Mr van Gogh demonstrates madness, while Mr Rousseau shows total ignorance of both drawing and painting. If the jury of other exhibitions prevents us from seeing such worthless, stupid things elsewhere, then I ask that it never be abolished' (September 1889).

Finally, let me quote an extract from a long study which appeared in the Mercure de France, admittedly a progressive paper, which was written by Charles Morice, a friend and supporter of Gauguin: 'Some of these eccentrics are not only naive, a few of them are cunning as well. Not all dullards are clumsy. True naiveness may be silly, but it does retain a grain of charm. Mr Henri Rousseau, a representative of this "species", who paints landscapes, portraits, pictures of this kind and dead nature in a most unusual way, does not succeed in irritating us. One smiles without anger at these absurd things, because they are honestly done. One can even discover oneself trying to imagine some merit in them: perhaps the simple curve of that pylon, that white patch of cloud, have a certain grace. But regrettably, the effort of imagination required is too great. This kind of folly, at least, is not tiring . . .'; and so on in the same vein.

We can only be bewildered by so much stupidity, especially as it comes from a man who 're-wrote' the Noa-Noa by Gauguin, somebody who knew his thoughts and his desire to rediscover the eternally primitive in his paintings, which goes back as far as the simple, small, wooden 'Dada'. One is surprised by this criticism voiced by a man who found it impossible to understand that Rousseau's painting, in its way, was just as perfect as that of his friend, and that, in contrast to the work of Cézanne and Van Gogh, it was the only painting which followed the same course as his own.

It is unnecessary to quote further examples of the lack of understanding, with which the leading papers greeted Rousseau's work during his lifetime. The general tone never changes. Even the first article ever devoted to Rousseau, written by Guillaume Apollinaire, hardly differs much from those by his other colleagues. It is just as stupid, insensitive and malicious.

But what is one to make of such a refined and sensitive writer as Alain Fournier, the author of the Grand Meaulnes, an almost completely naive novel and a best seller

which appeared between the two World Wars. It seems to represent the last flowering of the kind of fairy tale still recounted to small children in his home town of Berri and indeed elsewhere in France. He had the temerity to write to his friend in a letter dated April 18, 1909: 'In the case of Rousseau, it was a fallacy to say that his work is interesting merely because it is naive. As a "douanier" he is excellent, but not as a painter.' Such an attitude seems incomprehensible now.

Two of Rousseau's paintings belong to the famous collection owned by the writer Georges Courteline. Initially this collection was known under the name of 'Musée des Horreurs'. Nevertheless it was the first collection of naive paintings in the world.

The humorous paper *Cocorico,* in its edition of August 15, 1900, published a review of a museum, which was written by a certain Edouart Norès. The fact that this review appeared in a humorous paper is of course not surprising. The article nevertheless represents a milestone, in that it is the first to devote itself entirely to discussing naive painters and the phenomenon of naive painting, instead of concentrating on a few individual artists such as Rousseau, though in fact it fails to mention him. This alone would be a good enough reason to quote the article in full. For lack of space an extract will have to serve here, but it gives one a good idea of the attitude prevailing at that time towards naive painting.

'As he admits himself, Courteline's eye for spotting human absurdities stems in my opinion from a feature of his character. The spectacle of these absurdities awakens his deepest sympathy. As an astute observer of eternal folly he feels a deep affection for them; his pleasure in coming into contact with them is not tinged with bitterness or regret, he savours the various offerings with sincere pleasure. His incomparable translations of these works in the "Train de 8 heure 47", the "Ronds de cuir", the "Gaîtés de l'escadron" or the "Boubouroche", allow the human sympathy of the writer to permeate the detail of his descriptions.

It was this vein of sympathy in Courteline which occasioned the purchase of the first of the pictures now in the museum. He told himself that the important thing was to invest in an original collection, not of bad paintings he could pick up anywhere, but of strange and curious products which sprang from an industrious conviction on the part of the painters engaged in an endless and marvellous, if fruitless, struggle, of the men and women who were labouring under a misguided but honest belief in their calling. The result was the Courteline Museum.'

In spite of the evident attempt to please the owner and founder of the museum, the writer found himself unable, wittingly or unwittingly, to avoid all the clichés generally used when naive painting was discussed. 'Human absurdities', 'fruitless struggle', 'strange and curious products', 'eternal folly', 'misguided belief in their calling', and so on and so forth. The situation was hopeless, naive painting simply had no chance.

It is equally true, of course, that neither Cézanne nor Van Gogh made any impression on their age. That may seem strange today or, at worst, amusing.

To understand this sharp criticism one should bear in mind the contemporary situation. Suddenly labourers, custom officers, door keepers and old pensioners of every description started to paint and exhibit next to real painters. That came as rather a shock to the venerable top-hatted and elegantly dressed professional artists, all of them

furnished with diplomas and decorations and overwhelmed with commissions. It was a blow to the established order. In a curious way the reaction of these people reminds one of the attitude of doctors to homeopathy and other forms of healing. They were very close to taking naive painters to court for the unlawful practice of painting. The idea that one could be creative without having studied at a school of art never occurred to them. While the bastions of academic painting were still intact — and what was commonly termed modern art had not yet given all and sundry the freedom to express themselves in accordance with their feelings, without referring to the valid dogmas of painting — this kind of activity seemed to them utterly incomprehensible.

In one of his last works *La Tête d'Obsidienne,* André Malraux describes his impressions of a biennale in Paris: 'In front of a few paintings from Morocco, Yugoslavia, India, Mexico, scattered through the room — nay scattered through the world — clusters of visitors have gathered, not to see the work of painters foretelling the end of the world, but these hobby painters. Naive painting had legitimised itself everywhere, rubbing shoulders with painters whose time had not yet come. Naive painting had replaced pictorial and figurative painting, an area of enquiry which had exhausted itself'. Who could have put it better.

It is because of these very divergent views that I have persistently drawn attention to the ambiguous position the Naives found themselves in from the very start. It is difficult otherwise to understand why they were ostracised for so long and why, even now, there are still persistent attempts to exclude them.

The best one can do is laugh at the bad judgement shown by such people. One might start with Courteline himself, who assisted this process by inventing titles for all the pictures he picked up, from junk dealers in his quarter of Paris, to put in his collection. *Régates de mausolées, La vierge à moitié cuite, Huîtres de mois sans R, Impressions d'un suicidé, Maison de retraite pour l'enfance.* It is quite obvious that such pro-grammatic titles did little to help the reputation of naive painting.

The following intrinsically unimportant event will give an idea of how Rousseau was 'manipulated' and how our knowledge of him will always remain fragmentary. One of the pictures in the Courteline museum was the so-called *Portrait of Pierre Loti,* which is now in the Kunsthaus in Zurich. It was christened so by Courteline himself. But Rousseau's actual model, a certain Monsieur Frank, a writer of uncertain calling, who lived on the Butte Montmartre, recognised himself while visiting an exhibition of Rousseau's work in Paris, where this so called *Portrait of Pierre Loti,* which was on loan from the Kunsthaus, was also on view. As a result he wrote a long letter to the director of that establishment, in which he gave a vivid description of why Rousseau painted him sitting just there, the reason being that the smoking chimneys at the back of the picture were those of the first factories in the Saint-Denis Valley, which could be seen from his windows. Evidently Courteline thought Pierre Loti sounded better than Mr Frank, a famous nobody. Rousseau only knew Pierre Loti from illustrations of him in various newspapers. Perhaps Mr Frank was a model substituting for the real Pierre Loti. The red fez could point to an author of exotic novels. However, in view of the quality of the picture, such controversies are of little account.

The degree of importance Courteline attached to his pictures is demonstrated by

the fact that on the eve of the First World War he sold this very painting with an easy mind to the dealer Bernheim for a mere ten thousand francs (old francs), describing the purchaser to the trade as an idiot.

There were others who acted similarly. Round about this time the painter Robert Delaunay, convinced he was getting a good price, sold a masterpiece by Rousseau in his possession, the *Charmeuse de Serpents*, to the dress designer J. Doucet for fifty thousand francs, a ridiculous figure considering the extraordinary beauty of the painting. The picture had originally been purchased by Delaunay's mother; in 1936 Doucet left the picture to the Louvre.

Already ten years earlier, when works from the great American collection of John Quinn were sold at auction — Jean Cocteau wrote an introduction to the catalogue — another work by Rousseau, *The Sleeping Gypsy* reached a price beyond six hundred thousand francs.

From now on Rousseau's pictures increased in value with vertiginous speed. Monographs appeared in rapid succession. Rousseau became a marketable commodity. Delaunay would have leapt from his grave had he known that Rousseau's jungle picture, which in terms of form and execution is considerably weaker than his *Charmeuse de Serpents*, had recently fetched around seven hundred million francs (still old francs) at public auction in New York. It represents the largest sum ever paid for a modern work of art.

Was it this sudden change of opinion relating to Rousseau's work that prompted Courteline to exhibit his famous collection in the Galerie Bernheim Jeune between November 21 and December 2, 1927? The catalogue contains an interesting postscript, in which Courteline vehemently rejects the title of 'Musée des Horreurs' with which his collection is normally designated. He refutes the authorship of this title (which is untrue), and considers it much more appropriate to talk of a 'Musée du Labeur Ingénu' (Museum of Naive Works).

So what has happened? Was this about-face due to a sudden discovery on the part of Courteline that he had been mistaken in his earlier assessment, or was it simply due to the fact that the climate of opinion had changed in favour of naive painting? Perhaps he was feeling old and unwell and was trying to get rid of his collection at a good price? We will never know! His motives were certainly a little mixed. Nevertheless, his exhibition was still the first exhibition of unknown naive painters and represents a significant event in that it aided the rehabilitation of naive painting.

During the twenty seven years which separate this assessment from the first description of Courteline 'Horrors Museum' in 1900, much water has flown under the bridges of Paris and elsewhere. The campaign led by Apollinaire and supported by André Simon, to secure proper recognition for Rousseau's work, began to bear fruit. Poor Rousseau who died in 1910, was hardly in a position to enjoy these fruits.

The appreciation of naive painting by other artists

The people who best understood Rousseau and had the greatest affection for naive painting were really other painters.

Picasso owned five pictures by Rousseau, three were held in the vault of his bank, while the other two, amongst them the very small self portrait and the portrait of his second wife, accompanied him wherever he lived.

Even the famous banquet in honour of the 'Douanier' took place in his studio in the 'Bateau Lavoir', in Montmartre. The studio was burnt down some years ago. Picasso was also the first to purchase a painting by a compatriot of his, the naive painter Vivancos.

We have already heard that Delaunay owned pictures by Rousseau. Incidentally, the two fetish paintings by Picasso were first owned by him. Kandinsky, too, owned two small pictures by Rousseau, the only two pictorial paintings I saw in his house. They hung next to his own pictures in his beautiful apartment in Neuilly, which is practically opposite the Île de la Grande Jatte, once celebrated by Seurat. It is not surprising that he should write: 'I can only see a future for abstract arts and naive painting.'

Giorgio Morandi, the Italian Braque, only had a few reproductions in his studio in Bologna, a female nude by Rembrandt and drawings by Rousseau.

Another Italian ex-Futurist, Ardengo Soffici, was not only one of the first to buy pictures by Rousseau, but also the author of one of the first truly illuminating articles on him. It was published in the Milan paper *La Voce* in the same year that Rousseau died.

Léger confessed to me that his early paintings had been influenced by the jungle pictures of Rousseau.

The painter Maurice Vlaminck and the sculptor Zadkine collected works by unknown and naive artists; André Derain compared the intensity of expression in pictures by naive artists with the report from a rifle fired at close quarters. According to his confidant, the art dealer Vollard, Renoir loved the 'inimitable blacks' by Rousseau.

Who could be better qualified to pass judgement on the merits of Rousseau's painting than these world famous masters.

The manipulation of naive painting

But what of the other critics of Rousseau and naive painting generally? Regrettably, they progressed no further than admiring Rousseau . . . as a 'Douanier'; as they will soon be admiring Séraphine because she was a charwoman and Vivin because he was a post office clerk.

They continued to write article after article, book after book about all the smugglers Rousseau seized in his capacity as a customs officer (though he was only a humble official with the Paris customs office), about his adventures in Mexico (where he had never been), his gallant leadership during the war of 1870 (in which he took no part). They recounted the story of his ghosts, the leg-pulling to which he was subjected, the bogus invitation to have dinner with the President of the Republic and the equally bogus legion of honour; in short, they recounted all manner of jokes and lies, whose sole aim is to make Rousseau more romantic and more naive than he was in real life.

Perhaps Rousseau himself was responsible for these inaccuracies; or maybe his discoverers and later his 'managers', who competed with one another in embroidering his legend to promote his works. This may seem improbable but in any case the answer will never be known.

Of all the people who knew and visited him, painters, poets, writers, journalists, dealers and connoisseurs, not one of them took the trouble to test the veracity of all these stories, not even out of a sense of inquisitiveness.

Only in 1961, fifty years after Rousseau's death, when H. Certigny's book entitled *La vérité sur le Douanier Rousseau* was published, was the true stature of the painter's character revealed. It is not an easy book to read; very few copies were sold and it soon found itself ignominiously remaindered. But the Rousseau of his book is a completely different person, a mysterious being, alternatively naive and cunning, modest yet self-assured, a twilight figure who shunned the light and whose natural habitat was that of his own dreams.

The book did little to change Rousseau's image. It was only read by a few people, 'experts' included. The preference is still for other publications more felicitously written, superficially pleasing and more richly illustrated. The result is greater confusion and ignorance now than there ever was. But the subject is under a taboo! Investigations are not welcome.

Apollinaire celebrated Rousseau in poetry and prose, though only towards the end of his life. On the eve of the First World War he dedicated a special issue of his paper *Les soirées des Paris* to Rousseau, and he wrote a touching epitaph in pencil on the painter's tomb which the sculptor Brancusi, with the aid of the Mexican painter Orfiz de Zarate, later carved into the stone, following Apollinaire's pencilled lines.

But did that help in promoting a better understanding of Rousseau and naive painting? No doubt many will simply shrug their shoulders as if to say: can one believe all that? A big question mark will again hang over the whole subject of naive painting, as if all the things said and written to stamp out ignorance had been in vain.

Perhaps the vacillating assessment of Rousseau and other naive painters stems from Apollinaire himself, who could be changeable in his opinions. Apollinaire was generally seen as a defender of pictorial and literary 'extravagance'. The public did not really know whether to take him seriously. Was he talking tongue in cheek, perhaps in jest, or was it all a bad joke. Apollinaire's views, his discoveries and his extravagant praises are still treated with unjustified suspicion, a suspicion which will bedevil the discovery of naive painting for all time.

Actually, the real instigator of this pro-Rousseau campaign was by no means Apollinaire, but Alfred Jarry, a countryman of Rousseau's in the narrower sense for, like Rousseau, he was also born in Laval. They were bound together by many years of friendship. Jarry, an anarchic nihilist, much given to squabbling, and overwhelmed with debts, would occasionally seek shelter in Rousseau's studio in the squalid quarter around the Gare Montparnasse. It is quite possible of course that Jarry, like Apollinaire, did not think very highly of Rousseau initially, an opinion perhaps demonstrated by his action of cutting out the head of the portrait painted of him by Rousseau — it

had been exhibited in the Salon in 1894 — and filling it full of bullet holes fired from a revolver which he always carried with him. Doubtless Jarry understood better than anyone else the provocative role he was playing. It was a deliberate attempt to terrorise and annoy a complacent public. He did it to bewilder and shock and to rock the none too firm foundations of academic art. Perhaps he hoped this scandal would make the name of Rousseau more familiar. In any case, Jarry's eccentric behaviour was welcomed by all those intent upon disparaging naive painters.

And yet, a few years later, Rousseau was famous and his pictures commanded high prices. Those who stood to benefit from this situation were now concerned with separating him from other naive painters, by presenting him as extraordinary and unique, the product of an impulsive generation. Subsequently Rousseau's first dealer, D. Uhde, who assisted in the writing of the first book on him, selected four more naive painters to place alongside Rousseau. These were Bauchant, Séraphine, Bombois and Vivin. Uhde labelled them 'the great five' or the 'five primitive masters' because, unable to find any more Rousseau pictures, he had to look elsewhere. It was a step which determined the commercial boundaries of the Naives and effectively put other naive painters even more beyond the pale. As there were only 'five masters', all the rest had by definition to be small and undistinguished.

This anti-naive attitude reached its peak in a book entitled *Toute l'oeuvre peinte de Rousseau*, which was accompanied by a complete catalogue of Rousseau's work. The book was published in Italy in 1969 and was soon translated into several languages. The author, in all seriousness, had the temerity to write: 'Rousseau is not exhibiting his painterly innocence. On the contrary the struggle is within himself and is related to the desire for an academic title, which holds him spellbound. This is the insoluble conflict which gives his pictures their truly naive flavour. Seen thus, his case is closely connected with a particular historical moment which cannot appear again. Innocence, after becoming a style, has destroyed its own vitality'.

Poor Vivin! Poor Séraphine! Poor Rabuzin! Poor Epple! Poor O'Brady! Poor Boyadjian . . . ! You are worth nothing! According to this observation you should cease to exist. As your own vitality has been destroyed, your pictures are nothing but hallucinations, nightmares and ghosts or, at most, the peripheral phenomena of a particular historical moment.

Imagine, for instance, that abstract painting had lost its vitality after Kandinsky's first abstract watercolour because it had become a 'style'.

There are two possible explanations for this error of judgement. Either the author of this atrocity is unaware of the fact that there were naive painters before Rousseau, something which everybody knows, in which case one may attribute such statements to crass ignorance; or it represents a deliberate attempt to harm the cause of naive painting.

But no matter: naive painting has won. It has managed to cross that invisible barrier which separated it from critics and the public at large. It was important of course to catch the attention of a dealer, for he was the only person then able to promote a painter. Rousseau and a select band of others were at least lucky in this respect. The rest had to wait until after the war, when a new chapter in the history of naive painting begins.

The first international exhibition

The second and most important event in the history of naive painting was the first international exhibition, which took place in the Casino of Knokke-le-Zoute as part of the Great Belgian Exhibition of 1958. The idea came from an unjustifiably neglected writer and collector called P. G. Van Hecke. He was a supporter of the Flemish Expressionists and then of Surrealism in his own country. Although he was already very old, this daring idea showed that he had lost none of his taste, liveliness of mind and flair. The naive painters owe Belgium and especially Van Hecke an enormous debt of gratitude. He opened the eyes of an astonished world to their work and changed the position of naive painting overnight.

It is difficult to imagine now what significance the discovery of naive painting had in those feverish post-war years. History seemed to be quickening its pace and fundamental changes were taking place everywhere. This was especially true in the field of art, where almost everything became credible, acceptable and valid. Following the collapse of old standards, if not of old prejudices, the new age was single-minded in its determination to cast aside all blinkers. This new climate of freedom favoured, although indirectly, naive painting itself.

Those free of prejudice and able to keep an open mind regarded the appearance of this form of art, which until then had been more or less unknown, as a revolutionary event. In part this was due to a loss of respect for the usual galleries, who were not interested in the Naives, and to the disorderly and rapid increase in the number of new galleries, who no longer knew which artists to favour, and consequently exhibited without discrimination works by completely unknown people, including those by naive painters, a fact of momentous importance.

It was understandable that the second wave of French Naives such as Fous, Dechelette, Belle, Blondel, Lefranc, Desnos and many others should become known more easily without any need for financial support or exaggerated forms of publicity, but purely on the basis of supply and demand and the desire on the part of the public to purchase naive paintings. For almost one and a half centuries France had occupied a pre-eminent position in the world of painting, and Paris was the uncontested centre of the arts. The 'five masters', the only naive painters who were really well known, all came from France. At times they were seen as the poor relations of the Paris school, at others, because they were so difficult to place, as belonging to 'Réalisme Magique' and 'New Realism'.

The Yugoslav miracle

Alongside the mainstream of naive painting in France, a number of naive artists very surprisingly made their appearance in Hungary and especially in Yugoslavia, in a tiny village called Hlebine. These painters were as good and as varied as those in France. They were simple peasants, a fact which does no harm to the cause of naive painting. Their appearance threw up a number of questions concerning the nature of this art.

They reveal the hidden workings of naive creation, the constant factors and circumstances peculiar to this form of art. As we have already said, what we have here is a kind of Yugoslav miracle.

The appearance of peasant painting in Yugoslavia has shown that naive art is not confined to a particular country or people, an inherited gift, but that it can grow and flourish as well in the straw huts of Hlebine as in the urban jungle of Paris.

It does not arise from a particular historical coincidence, a random event, but is the result of the law of cause and effect. I will try to show later that this law is all-embracing and responds to a historical necessity.

At the time the 'discovery' of naive painting in Yugoslavia was all the more surprising, because nothing was known about this form of painting from any other country. Until their work was exhibited in Knokke and in the United States pavilion at the World Exhibition in Brussels, even the magnificent American Naives were unknown in Europe.

Thus nothing was known of the rebirth of naive art on Haiti, which had come about during the war in the following way. An American called De Witt Peters, a teacher of English in Port-au-Prince, was startled by some murals he saw in a tavern, not far from the capital, which had been painted by the owner. His name was Hector Hyppolite. At one time he had worked as a decorator, and had now almost completely given up painting. But Hyppolite's murals gave De Witt Peters the idea of distributing pieces of canvas, brushes and colours amongst the natives of the island, in the hope of awakening in them a talent which would cause them to produce miracles of poetry and feeling in an uncorrupted state.

As a result of this experiment there was a great unfolding of natural talent on the island: Préfète Duffaut, Casteria Bazile, Abelard, Enguerrand Gourgues, Toussaint Auguste, Rigaud Benoît, Louverture Poisson — and many more. They demonstrated a remarkable zeal and even decorated a new cathedral with their murals, a rare if not unique event. This state of affairs lasted until the desire for profit and hard currency took over and, regrettably, they started to mass produce works for an expanding export market.

The interesting part of this Haitian event is the role played by De Witt Peters. For, although naive painting is practised much more widely than people imagine, only very few naive artists manage to earn money by selling their work. Potentially naive painters feel inhibited because they lack any formal knowledge of painting and suffer from a feeling of inferiority in relation to other painters, which usually is quite unjustified. They need help, encouragement, a salutary dig in the ribs, a little human understanding for the creative process to be released. De Witt Peters was such a catalyst; he triggered off an explosion of latent talent. He was the forerunner of several other individuals who, under various circumstances, promoted naive art. Would the naive carpets woven by Egyptian youths in Harrania, close to the Giseh Pyramids, ever have been made, had not Ramses Wissa Wassef provided the necessary stimulus? Almost certainly not! Nor would we have the remarkable drawings from Mithila, a kingdom in India at the foot of the Himalayas, had not a compassionate lady distributed the necessary materials amongst the uneducated local women (who had never painted before) in order to save them from starvation, for she found a ready market for their work among connoisseurs.

That such distant products of naive art should be forgotten is understandable. But naive painters in Germany, Belgium, England, Holland and in many other countries geographically much closer, were also forgotten. Unnoticed remained the many men and women of the last century who, in spite of the sullen indifference they were accorded, left behind them works of the very highest quality.

Apart from a few enlightened people within Sweden, who had ever heard of Josabeth Sjöberg, who was born in 1812 and died in 1882? At the age of 52 she started to keep an intimate diary, the greater part of which is now in the Stockholm Museum. Its pages are filled with delicate water colours and drawings of daily events. There are views of the town she lived in and cosy 'Victorian' interiors, showing her standing by a harpsichord or lying in bed, the maid going about her daily work or the women's work-room. All these little scenes are sensitively observed and charmingly executed.

Then there was Alois Beer born in 1833 in Dobrušce in Bohemia, who left behind something very similar except that his water colours were done for inclusion in an actual newspaper.

Paul-Émile Pajot (1873–1929) was motivated by a similar idea. A seaman from Vendée, he ran a ship's newspaper, in which he recorded everything he thought worthy to be handed down to posterity.

The roll of naive painters, unknown and unsung, is inexhaustible. There was Oluf Braren (1787–1839) for instance, a teacher in Braderup, the undisputed father of German naive painting; his friend Christian Peter Hansen (1803–1879), also a teacher, who was undoubtedly influenced by him; Adalbert Trillhaase, a remarkable painter, although his life and work already reach well into the twentieth century; similarly Adolph Dietrich (1877–1957), peasant, hermit and naturalist from the Lake Constance area in Switzerland.

There was Louis Delattre (1815–1897), who was born in Geneva and was a photographer, decorator, inventor and painter of note and his young friend Seraphin de Rijke (1840–1915) from Laethem-Saint-Martin in Belgium who had an obsessive need to paint; Theophilos de Lesbos (1886–1934), who was discovered by Le Corbusier; and Niko Pirosmanichwili (1860–1917), who travelled through his native Georgia painting often very large decorations, signs and murals in exchange for his board and lodging; and a Hungarian pharmacist called Csontváry (1853–1919) who saved every penny he could in order one day to be able to close his shop and sit out on the street and paint, an ambition as simple, naive and inconsequential as the desire to play the guitar under a moonlit sky.

Up to the time that Van Hecke organised his remarkable exhibition in the Casino of Knokke-le-Zoute, no one had heard of any of these painters.

The advocate of naive painting

How did Van Hecke know of the existence of naive painting? Quite simply through my books. I am convinced of this because he left the selection of exhibitors to me and

asked me to write an introduction to the catalogue. Let us not forget that up to then only six books had been written on the subject of naive painting, and I had been the author of these. I should make special mention of my book entitled *La Peinture Naïve*, which appeared in 1947 and was the first and only work to deal with the complete history of this form of art. Nor should one forget that the two works written by W. Uhde, which only dealt with Rousseau and the other four 'great masters' were quite unknown to Van Hecke, while Sidney Janis' book *They Taught Themselves*, which appeared in 1942, dealt exclusively with naive painting in America.

If we compare the small number of books published during the first half of this century with the more than fifty works which followed in less than twenty years after the exhibition in Knokke-le-Zoute, we can see how the cause of naive painting has progressed.

At this point I should like to digress a bit, if I may, and tell you a little about myself. Not out of vanity, but because my work as critic and author was, at a certain stage, closely identified with a defence of naive artists and with the popularisation of naive art generally. Would, for instance, M. O. Bihalji-Merin's *Das Naive Bild der Welt* (Cologne 1959) have been possible without my second book *Les Peintres Naifs* (Paris 1956), published some three years earlier?

I discovered naive painting quite by accident during the last war. I had previously played an active role in promoting the flagging fortunes of Abstract Art. After the malicious attacks by Michael Seuphor, the press ceased to take any interest in Abstract Art. Abstract artists were as condemned and as misunderstood as naive artists. I knew Kandinsky, Delaunay and Mondrian extremely well. At twenty-two I published the first monograph on Herbin. Léger and Delaunay provided illustrations to my volumes of poetry — the sins of my youth. The first articles, at least in France, on Kandinsky, González, Calder, Pevsner, Vasarély, Atland, etc., appeared under my name. I was the author of a lavishly illustrated book, which was published in a limited edition of one hundred copies, of original graphic work by Picasso, Miró, Arp, Max Ernst, Léger, Giacometti, Calder, Hélion, González, etc., all signed by the artists themselves. At the outbreak of war they left Paris. Some went to the United States, others crossed over into the 'unoccupied zone'. I found myself alone and isolated, brooding over the fate of the world, and the events unfolding before my eyes, wondering what effect all this would have on the future of painting. The abstract artists who had been my friends predicted an age of darkness and the end of painting. Was no postponement, no regeneration possible?

My search for a way out of this gloom took me to a little street market and the purchase of my first anonymous naive picture. I started to write about naive painting. I set to work defending naive painters against the scoffers and critics, a task made all the more easy, as the role of the defender of lost causes was one I was familiar with. I compiled a *Lexicon of Amateur Painters* (Basel 1967), and I have just finished writing my five hundredth introduction for an exhibition of naive painting.

But enough of the sordid and yet somehow miraculous events surrounding one man's life. The destiny of others may or may not have been influenced by them.

A Yugoslav spring turns into a global summer

Let us return for a moment to the naive painters of Yugoslavia, who best demonstrate the interrelated influences at work in naive painting. A swineherd, a young boy of sixteen or seventeen who looked after his father's pigs, was using wrapping paper from the butcher's shop in Hlebine, where he lived, to scribble crude drawings, anything that caught his fancy, real or imagined.

One is reminded of Giotto sketching the sheep he was tending in the Tuscan hills, before starting his apprenticeship as a painter.

This was in 1931. The fairy tale prince appeared in the person of a painter called Krsto Hegedušič, already quite well known at that time, who was holidaying in Hlebine. He was not a naive painter himself, but he encouraged Ivan Generalič with sensible advice and awakened in the young boy a feeling for the beauty of painting, while taking care not to influence him in any way. Expressed in scientific terms, he served as a catalyst. I have already used this term in connection with De Witt Peters, who prepared the ground for the explosion of naive painting on Haiti.

A believer in the Gospel of Reincarnation, Hegedušič, following in the footsteps of Tolstoy, directed himself towards the people and, without realising it, found the people. This providential convergence brought about a fruitful partnership, which was strengthened by an enduring friendship. In the same year Generalič began to show his work to a group of painters called 'La Terre' ('the earth'), to which he brought new vitality; he also took part in most of their exhibitions. Not long after, Generalič was joined by two other peasants; Virius, who was shot during the war, and Franjo Mraz, another classic example of naive painting. The years after the war saw the arrival of their imitators and with it a great expansion of naive painting in Yugoslavia. This post-war generation of painters was still made up of peasants and artisans. Kovačič, Filipovič, Gaži, Mehkek and Večenaj are some of the most familiar names, together with Feješ, a labourer, Skurjeni, a tramp, Lackovič, a post office clerk and Rabuzin, a joiner and one of the greatest living naive painters. They represent the progressive wing of this art, working in oil and, following an older tradition, painting on glass in the so-called 'églomisé' manner. The centre of naive painting lay in Croatia from where it gradually spread to the other three Republics, becoming well established in Serbia, which is the second most important centre of Yugoslav naive painting. These developments in Yugoslavia gave naive art as a whole a tremendous impetus.

After the historic exhibition in Knokke-le-Zoute, naive art became irresistible. Exhibitions followed in rapid succession. Czechoslovakia, Yugoslavia and Switzerland started to hold regular festivals of naive art, usually followed by an international seminar on naive painting. Museums of naive art were founded in France, Yugoslavia, Brazil and Italy. Pictures by naive artists made their appearance on sweet packets, stamps issued by the French and Yugoslav post office, on Swedish matchboxes, and as posters. Soon the 'naive' style became fashionable and was reflected in clothing, cosmetics and the development of a pseudo-naive style in advertising posters. Naive painters now spring up everywhere, most of them frauds. But in the meantime prices for works by naive artists keep rising . . . and rising.

An especially rich vein of naive painting can be found in Brazil where painters, men and women, young and old alike, gather together in the Square of the Republic in São Paulo to sell their work in the shadow of the skyscrapers.

The glorious Yugoslav spring, so full of promise, was followed by the scorching heat of the Italian summer. The first exhibition of Italian naive painting, which took place in Rome in 1964, was able to bring together twenty artists. In 1974 three hundred naive painters are listed in Bolaffi's catalogue. Before the war only two such painters were known by name. They were Orneore Metelli and above all Antonio Ligabue, who showed certain affinities with 'art brut' and was probably the greatest of all Italian naive painters. He was a tramp who travelled around the Po Valley, living off charity and public assistance.

Due to two somewhat divergent factors, Germany has remained the most backward area. Firstly, the public has never had the opportunity to look at naive pictures and to understand and appreciate them. In the most important European countries it was more or less possible before the war to see examples of naive painting, but in Germany such art was considered 'degenerate' and therefore prohibited. The few pictures by Trillhaase still on exhibition were removed, and his family were only able to save his work by secretly bringing it across into Switzerland. Dealers and museums, who had surreptitiously locked away their stock of naive paintings, were largely ignorant of their worth. Germany itself was in a period of reconstruction following the devastation of the war and people had other things on their mind. These factors prevented the recognition and spread of naive painting. The situation was exacerbated by a number of books, whose authors showed a lamentably poor knowledge of their subject.

Since the foundation of the Clemens-Sels Museum in Neuss which, happily, has approached the subject in an objective manner, this state of affairs has changed. Fortunately, too, there are many good naive painters in Germany and an understanding public to appreciate them. Otherwise painters like Dieckmann, Minna Ennulat, Odenthal, Raffler and Söhl would have remained entirely unknown. I mention these few in alphabetical order, to avoid being accused of prejudice. However, I would not like to pass on without making special mention of Bruno Epple, to my mind the greatest living German naive painter. I have no ulterior motive in extending to him my most cordial greetings.

The vitality and spread of naive painting in Germany is also confirmed by the exhibition entitled 'Ships and Harbours', which was jointly sponsored by the magazine *Stern*, the Altonaer Museum Hamburg and the West-Bank AG. The exhibition revealed the existence of hundreds of naive painters quite unknown until then.

The message of naive painting

'It is the vanquished who inherit the earth, Jimmy. It's always like that after a war . . .', words spoken by Curzio Malaparte in his book *The Skin* to his American friend in command of a transport division, which is advancing on Rome to liberate it.

During that quarter of a century devastated by war, the world saw the flourishing of an art form for which it had unconscious need and which helped it to survive.

These twenty-five years have done more to foster a general acceptance, a knowledge and a love of naive painting than the previous one hundred years ever did.

Claude Lévi-Strauss, a famous scholar and a professor at the Collège de France and one of the fathers of Structuralism, confirmed this when he said: 'As far as a resurgence of graphic art is concerned, I shall expect more from what is today called naive painting than from all the efforts of Cubists and abstract artists'.

If naive painting appears at a moment in history when the pre-industrial, agrarian, paternalistic society is in collision with the modern age, then it will find very little recognition. To be really able to understand and love this form of art, it will be necessary for the modern age to come to an end. Only once industrial progress has reached the acme of its development and man finds devastation and disillusion stretching endlessly before him, only then will naive painting really flourish as a kind of antidote to a mechanised waste land. Naive painters derive their ability to survive from the fact that, in the face of a reality whose only constant state is one of flux, they are pursuing a reality of their own, a calm vision of a long lost paradise, a Garden of Eden, a state of happiness whose location could be found through the act of painting. All year the town dweller dreams of and yearns for his holidays, those glorious four weeks of escape from the drudgery of his job and the ugliness of his surroundings. And yet this feeling only dimly conveys the passionate longing felt by the naive painters for their form of escape.

The strength and, at the same time, the attraction of naive painting can only be explained by the fact that these pictures have been painted with the 'eyes of the soul', a term already used by Shakespeare and really biblical in origin: 'I have pondered upon all things with the eyes of my soul'.

Why is this longing for an uncorrupted world manifested through a visual medium? Freud is right when he says 'visual thinking is a more unconscious process than verbal thinking, the former is older than the latter'.

To understand the message of these 'gift-laden innocents', as one might describe naive painters, one only needs to look at the traffic congestion, the polluted air in our cities, the ever increasing noise which assails us day and night, the spoliation of nature, the increasing spread of automation and the progressive dehumanisation of the individual — hardly an exaggerated catalogue of woes.

In these brutal, monstrous and yet somehow wonderful times, when a man can walk on the moon and for a brief period leave behind all memory of earthly things, of the daily worries which are his reward for working for an uncertain future, a future which frequently appears sordid and bleak, in such times the azure skies, the crystal air and the bright light of naive painting are the best remedy, and perhaps the only therapy. Here are vitamins for the soul. Just to look at one of these pictures makes one feel better, the greyness of everyday life regains a bit of its colour. There is no other explanation for the present popularity of this form of painting.

It is no accident that naive painting, which provides a kind of experimental ecology in which to explore various artistic possibilities under changing environmental conditions, should appear at the same time as 'pop' art, with its attempt to redefine the visible world. Both these trends, naive and pop, are trying to rediscover an image of reality

distorted by Cubism and finally abolished by abstract art. In their very different ways naive artists and pop artists are attempting to save what they can, to salvage what is not yet beyond recall. In the meantime the 'demolishers' of art, as Malraux called them, continue to scavenge amongst its ruins, replacing the picture with a 'concept', the brush for a nation, the desire for a deed. A gesture is now counted a work of art.

These 'happenings' have reduced painting to the level of the gutter.

This attack against contemporary art or, at least, against its abuses, might have created the impression that I am against all art which is not naive. Quite the contrary, I very much welcome non-naive art, but I am against the obscuration of facts and ideas. What can a naive picture have in common with a 'moulding' of polystyrol. Absolutely nothing! They are two quite separate things and represent diametrically opposed ways of looking at the world, two contrasting ideologies. The very different and quite irreconcilable feelings engendered in the observer stem from the frosty appearance of the one and the infinite humanity of the other. The one is the result of ratiocination, whereas naive art is drawn from the well of human feelings, desires and dreams. On the one hand hyper-realism, on the other naive painting, the head versus the heart.

Which of these two realities will be mirrored in the art of the future? I am neither a futurologist nor a clairvoyant. The tea leaves do not speak to me.

I am only too familiar with the accusations levelled at naive painters, their apparent preference for the past and their taste for painting rather old fashioned pictures as if their point of departure were the old fairy tale formula 'once upon a time . . .'. But what were the subjects painted by primitive painters and the early Gothic masters after Giotto? Did they not always turn to the life of Christ and the deeds and miracles performed by the saints?

Another endlessly repeated reproach is that naive painters are clumsy. But they are only showing men and women as they are and as they see themselves, naked and abandoned in their world of suffering, but borne up by an irresistible desire for laughter and a deep humanity. Naive painting reflects the ecstasy of visible things.

Thomas Mann recognised this when he wrote: 'In the final analysis the naive element is the vital ingredient of existence, of all reality, even at its most self-conscious and intrinsic level'. Arthur Schopenhauer, another German, expressed this idea in a similar way: 'Art will always speak through the naive and child-like language of intuition and not through the abstract and solemn language of reason. Its answers are transient images and not general and permanent ideas. Thus every work of art, painting or statue, every poem or dramatic scene will answer this question intuitively'.

All painting is difficult to explain. Important is that sudden spark of intuitive understanding, which passes between the picture and its beholder. This is especially so in the case of naive paintings, these tender creations which come from a 'pure heart' and are made by 'spotless hands'.

One may love these pictures, or one may not, but one small difference does separate naive painting from other forms of painting, and it is this: a naive picture has the power to move us to tears because it conveys with a powerful immediacy the spontaneous outpourings of the painter's heart, his dreams, his despair and his joy.

Look at the following pictures. Do they not have the power to move and to enrich us.

A feature of naive painting is the way in which the identity of the painter who, after all, does not feel himself to be an artist, frequently disappears behind his work. This is especially true of the United States of America, where many of the travelling painters, to whom we are indebted for those charming scenes of every day life in the new world, recorded with photographic precision, remain unknown. This picture, which shows a father returning home to his family, is typical for the detailed manner in which carpet, birdcage, chairs, wallpaper and curtains are painted. It documents the property of the people represented in the picture. The fact that the figures are stiff, their proportions and movements are in part wrongly drawn from an anatomical point of view, and the treatment of perspective reveals the hand of an untaught painter, in no way reduces the charm of this family portrait, reflecting secure domesticity full of warmth and life.

The Sargent Family, **1800**
An unknown painter from North America

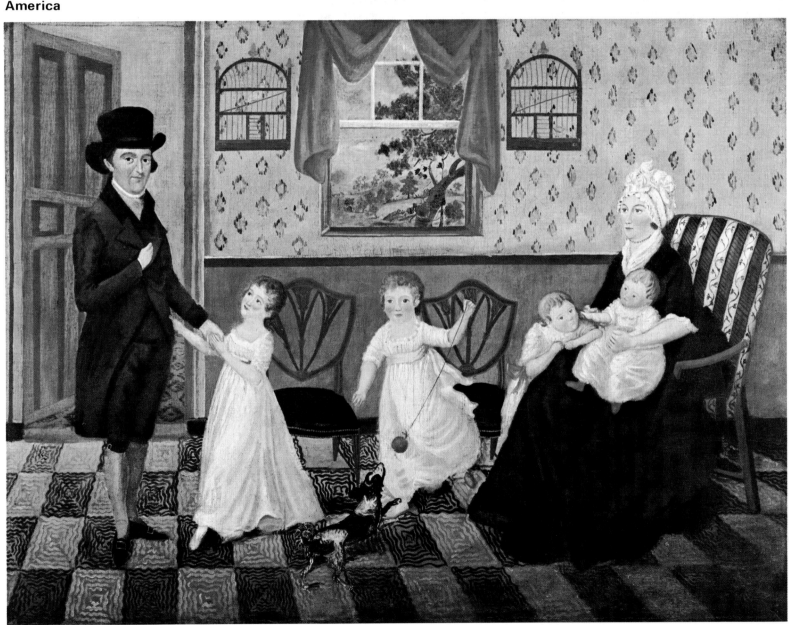

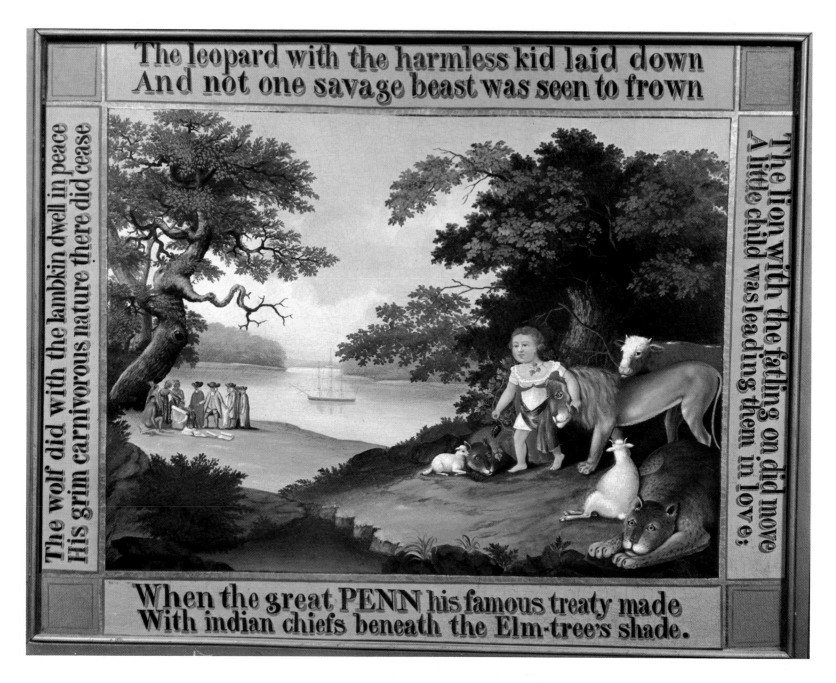

The leopard with the harmless kid laid down
And not one savage beast was seen to frown

The wolf did with the lambkin dwell in peace
His grim carnivorous nature there did cease

The lion with the fatling on did move
A little child was leading them in love;

When the great PENN his famous treaty made
With indian chiefs beneath the Elm-tree's shade.

Edward Hicks
William Penn Negotiating with the Indians

Edward Hicks was born in 1780 in Attelborough (now Langhorne) in the county of Bucks, Pa.; he died in 1849 in Newtown, Pa. (USA).

Hicks is undoubtedly the most famous naive painter of the New World and one of the first to leave behind a description of his life, which sets him apart from many other painters about whom we know nothing.

Between the ages of 13 and 20 he worked as an apprentice to a wheelright. Then he suddenly switched his trade and started to paint articles of every day use such as carriages, shop signs, signposts, etc; he called these his 'specialities'. After an illness he turned to religion. He became a Quaker and a preacher, but continued 34

his commercial painting to support himself. After teaching himself the rudiments of painting, which he did by diligent and daily practice, he used it to further his missionary ends. During this time he painted *The Kingdom of Peace* (1830–40), a vision of a new earthly paradise in which wild animals live in complete harmony with men, whites as well as Indians. Hicks' paintings are remarkable, both for their technique and for their moral sublimity. His picture entitled *Summer on Cornell Farm* (1848), where proud horses, healthy cattle and fat pigs are proof of a well managed breeding programme, has a pervasively paradisiacal atmosphere.

Hicks' memoirs, in which he writes a great deal about his religious experiences, show a close relationship between his paintings and the spiritual world of Quakerism.

Edward Hicks
Summer on Cornell Farm in Pennsylvania,
1848

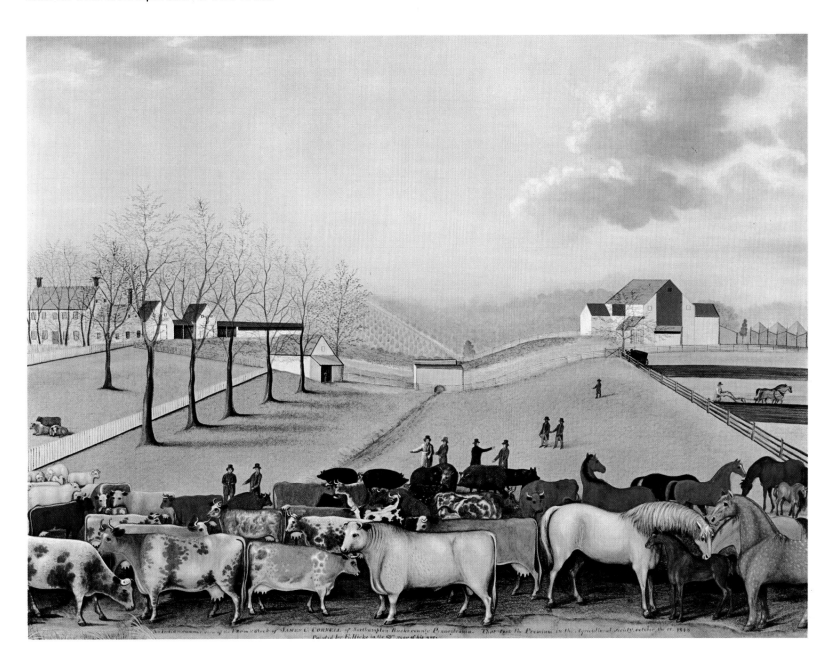

Patricia Barton
The Lion and his Friends

Patricia Barton, born March 2, 1928 in Los Angeles (USA), now lives in Marcillac (Dordogne).

Patricia Barton comes from a poor background and has followed many occupations, even that of a bar maid. But her paintings have a rare distinction and refinement, which is revealed in the careful manner of their execution, as well as in their linear rhythm and colouring. One is reminded of the visions of the English Pre-Raphaelites (of whom she had never heard), though here the vision has undergone a 'naive' correction, and the colours are more reminiscent of an early Vuillard. Her output is very small, probably because every one of her pictures requires an enormous amount of time to complete. The subjects of her paintings, executed in a rather stylised manner, are landscapes, people and animals, cats and dogs.

In 1975 she was awarded the Pro Arte Prize of Morges (Switzerland).

Gertrude O'Brady (actual name Mac-Brady) was born in Chicago in 1904.

If it were necessary to prove that true naive painting is not a free gift, but always a kind of obsession which requires sacrifices, then the American painter Gertrude O'Brady would provide a ready example. Following a severe illness she went to Paris shortly before the Second World War. There she started to paint quite by accident, after someone had given her

a small box of paints to distract her mind and ease her suffering. What happened then can only be described as a miracle. In two years she painted about sixty pictures of such rare quality, that today she is probably regarded as the greatest naive painter after Rousseau. When America entered the war, she was put into a concentration camp, where she could only work in pencil, as colours were no longer available. She drew all her fellow sufferers, jockeys, priests, cooks and society ladies. Her drawings, by some miracle, seem to approach Clouet, Fouquet, even Holbein. But after her release and her return to ordinary life, painting and drawing ceased to be part of her life and she relapsed into her old illness. Her traces lead from clinic to clinic, until they finally vanish. A veritable meteor!

Gertrude O'Brady
The Balloon

Morris Hirschfield was born in 1872 in a small town in a part of Poland formerly belonging to Russia; he died in New York in 1946.

The utterly astonishing Hirschfield is one of the greatest painters the world has ever known. After emigrating to America in 1890, he worked in a ladies fashion house. He had a predilection for naked women, whose underwear, shoes and other accessories he painted with great precision so that one is led to believe that Hirschfield was a fetishist. His subject matter reveals his liking for choice and tender detail, which elevates his pictures to great works of art. They remind one of old Persian paintings, not only in their naive manner but also in the execution of their ornamental and decorative detail.

Regrettably Hirschfield left behind no more than seventy pictures, which have all gone to large American museums and private collections. An irreplaceable loss for Europe!

Morris Hirschfield
Girl with Angora Cat, **1944**

Vincent Haddelsey was born in Lincolnshire (England) in 1929.

As is only proper for a good Englishman, Haddelsey has a weakness for horses. He is an excellent horseman himself and takes an active part in horseracing and foxhunting. He takes this to heroic extremes, by participating in the famous 'rodeos' and 'charriadas' in Mexico during his many extensive travels. But there comes a moment when a predilection turns into a passion which seeks to express itself. Something visible and permanent is required, some evidence of one's existence. Prompted by this inner necessity, Haddelsey began to paint. His pictures are the uncorrupted outpourings of an innocent heart. They are typically English (as the paintings of Micheline Boyadjians for instance are typically Belgian). This is not just because he paints English landscapes, but because his manner betrays the typically English quality of reserve. He employs muted tones, grey, green and rust-red, colours well suited to a foxhunt in Autumn.

In 1969 he won the Great Prize of Lugano. He has also published two very beautiful books on horses which, as is only proper, he has illustrated himself.

Vincent Haddelsey
The Foxhunt

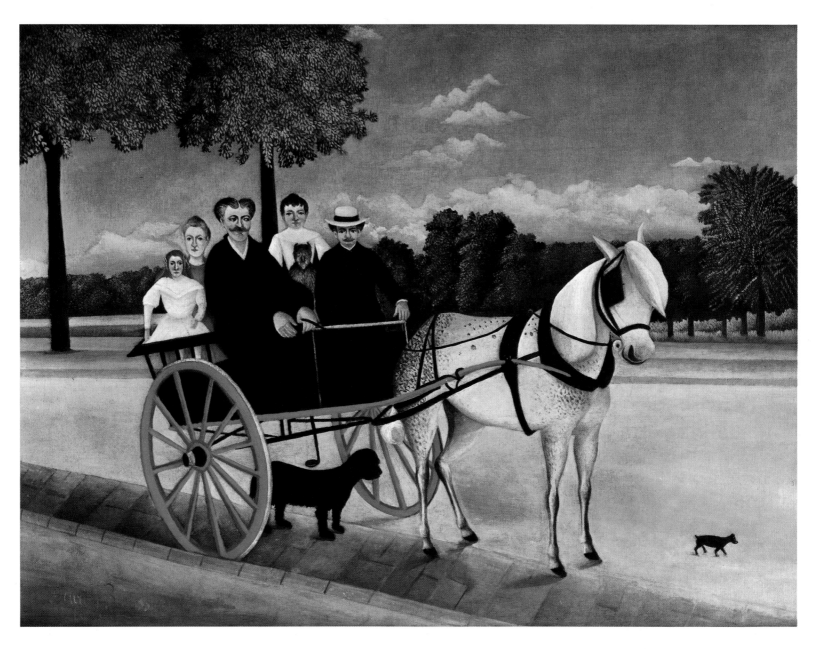

Henri Rousseau
The Carriage of Père Juniet, **1908**

Henri Julien Rousseau was born on May 21, 1844 in Laval and died on September 2, 1910 in Paris.

To date more than a dozen important books have been dedicated to the greatest naive painter of all time. But none of them has really been able to penetrate the secret of his personality. Some deal in imaginary accounts of his life while others try to outdo one another in interpreting his work. This regrettably, has led to a multiplication of fanciful images of Rousseau, which will soon be as numerous as the real ones. Even the best of these works, written by H. Certigny, contributes little to an understanding of Rousseau as a painter, although it follows the minutiae of his daily life.

There comes a point when one is tempted to ask oneself whether the 'Douanier' really was naive or whether, on the contrary, he was highly intelligent and merely playing the game, because that was

what his fans expected. Anecdotes confirming both possibilities abound. Was Rousseau being naive or cunning when he said to Picasso 'the two of us are the greatest painters of our time, you in the Egyptian style and I in the modern style'. Another time, to make fun of him, friends persuaded him that he had been invited to the Elysée Palace by the President. A few days later Rousseau told his friends: 'I went to the palace . . . the President came to open the door, but he asked me to come back another time when I was more properly dressed.'

Once a casual acquaintance of his suggested they undertake a fraudulent bank transaction. Rousseau agreed, was apprehended and had to appear in court. Suddenly he remembered that at one time he had been a member of a Freemasons Lodge and immediately requested legal assistance. His accomplice was sentenced to a term of hard labour, while he was only placed on probation. Upon the pronouncement of his release, he said to the judge: 'In order to thank you, I shall paint a picture of your wife!'

Rousseau's paintings are as various and

Henri Rousseau
The Dream

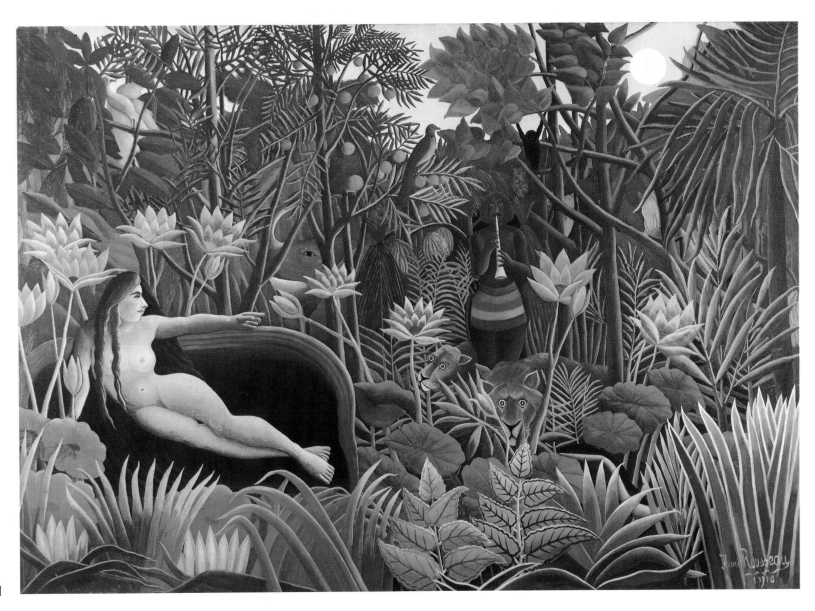

41

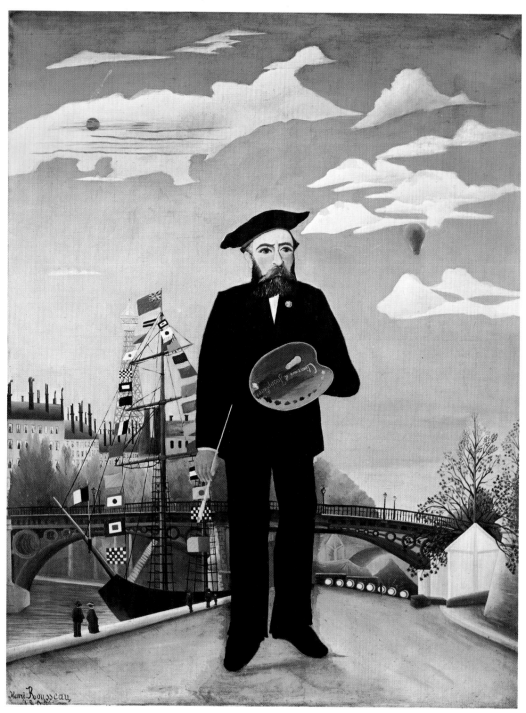

Henri Rousseau
Self-portrait, **1895**

diverse as his life. At times he produced impressionistic sketches, precise, tidy, lively without any trace of clumsiness; then he painted a self-portrait, where the legs end up by being much too long. His correction is so superficial that one can see it with the naked eye. How is this to be explained? What remains are some beautiful paintings, as beautiful as any by Picasso (Rousseau was right in his assessment of Picasso). All we can do is to admire them without reservation and to regret the fact that his contemporaries were unable to get to the bottom of this duality, which will always remain a mystery.

42

Camille Bombois, born on February 3, 1883 in Venaret-les-Laumes, died on June 11, 1970 in Paris.

Bombois came from a rural background and was a man truly obsessed by painting. He was a naive painter, of course, for he was entirely untaught. After an eventful life, during which he tried his hand at many jobs, he settled down as a compositor.

As he had to work at night, he was able to give the day over to painting.

For his subject matter he drew mainly upon his surroundings and events with which he was familiar. He painted several circus scenes, an environment he knew well, having once worked in a circus. They are painstakingly executed and show a strong sense of reality. This is also true of the many voluptuous and very 'erotic' nudes he painted. No detail, not even the most intimate, is omitted. With one or two exceptions, his wife served as his model.

As one of the 'great five' he quite soon came into fame and money. But unlike many naive painters, once they feel they have 'arrived', he continued to paint with the same sincerity and dedication he had always shown. It was only towards the end of his life that his paintings lost some of their expressive and decorative greatness, when American dealers asked him to confine himself to very small pictures which could be easily concealed from customs officials. Upon entering his studio, the most prominent feature was an enormous safe and next to it his easel, which he no longer had any need for. The paintings which once covered his walls had been sold, and the little postcard-size pictures he was working on were hidden away in drawers.

Commercial success can spoil a naive painter as readily as any other.

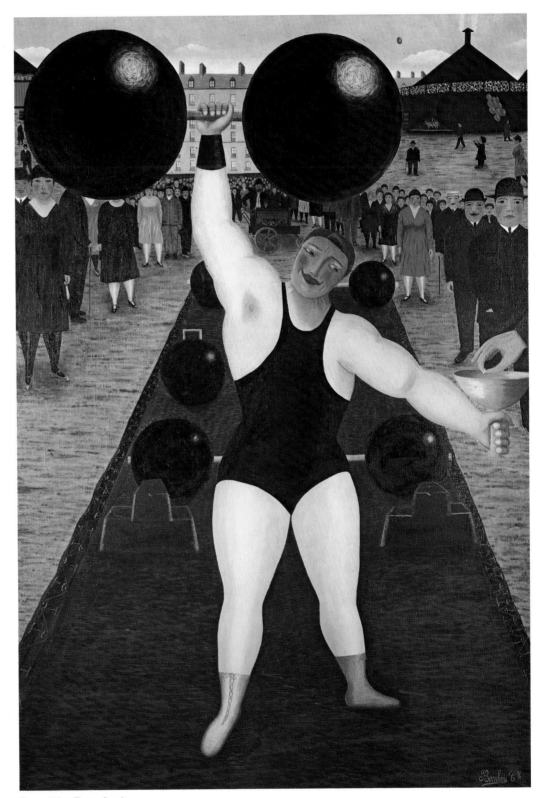

Camille Bombois
The Weightlifter, **c. 1930**

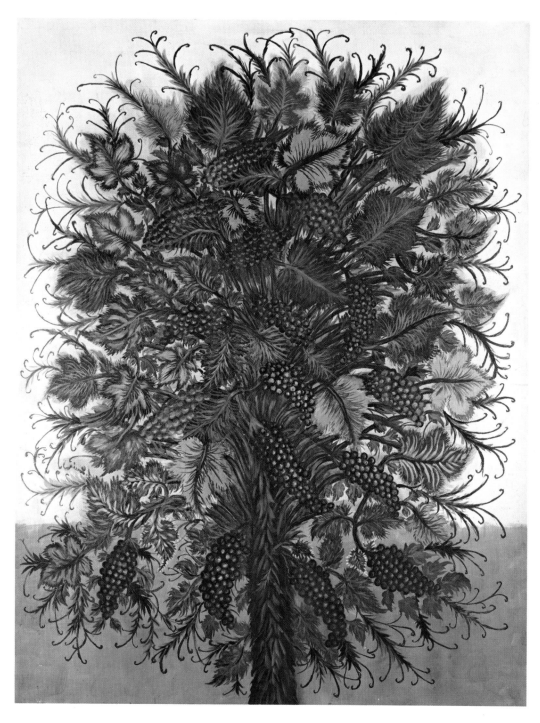

Séraphine (proper name Séraphine Louis), born on September 3, 1864 in Arsy (Oise), died on September 11, 1942 in Clermont (Oise), France.

Poor, miraculous Séraphine! She remained a spinster all her life and lived in extremely modest circumstances. She worked as a maid for M. Uhde and only had one pleasure in life, which was her painting. Her pictures are extremely flowery and belong to the realm of fantasy. All her complexes seem to be buried in them. Her piety may or may not have been affected, but a little lamp constantly burnt in front of her statue of the Virgin, and the burning bushes in her paintings seem to be fanned by a similar light. At first sight they look beautiful and angelic, but a more detailed inspection does not seem to bear this out. One can see sexual organs, barely concealed amongst the leaves, pistols, flower petals and branches; excellent material for a psychoanalyst. Séraphine ended her joyless existence in an asylum. Her one hold upon life, which was her painting, came to an end. The financial crash of the 'thirties, when her regular dealer stopped buying her pictures, finally dimmed her reason completely. She told people that the bishop of her diocese had made her pregnant. She had to be locked up and her flame was quenched for ever. She was one of the most beautiful and fantastic amongst the naive painters.

Séraphine
Bunch of Flowers with Grapes

Jean Eve, born in 1900 in Somain near Douai, died on August 21, 1968 in Meudon (France).

At first sight Jean Eve seems to be a border case. Is he naive or not? Yet he is a true naive painter because his pictures, for all their obvious perfection, do reveal occasional traces of clumsiness so characteristic of naive painting. His themes are essentially naive, and his paintings show an affinity with nature and a depth of emotion, which is something most painters lose once they have been taught to paint 'correctly'.

Jean Eve was self-taught and worked as a government surveyor. But increasing success soon allowed him to give up his job. His paintings were bought by many museums, both in Europe and in North America. He was the youngest artist in a touring exhibition entitled 'Maîtres Populaires de la Réalité', which in 1937 went to New York, London and Zurich, and which consolidated his reputation.

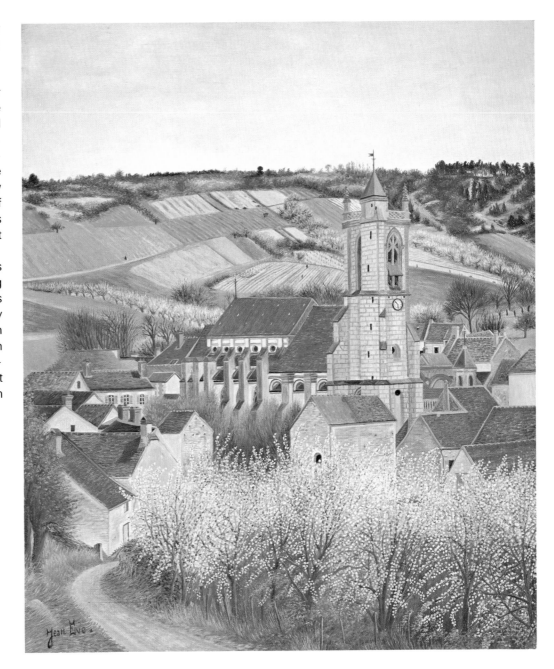

Jean Eve
Landscape with Village

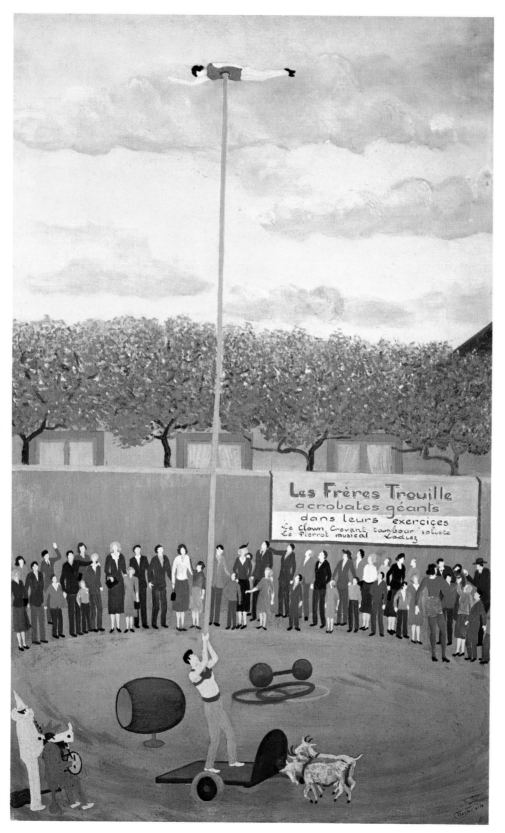

Louis Dechelette, born on January 11, 1894 in Cours (Rhone), died on November 19, 1964 in Paris.

Dechelette was the reincarnation of one of those French artisans of a bygone age. He was a walking anachronism. He travelled through France following his profession, which was that of a decorator, for he belonged to the famous 'Compagnons du tour de France', who had been doing this for decades, prompted by a love for the profession and a desire to learn.

He applied this quality of integrity to his painting. But his work also mirrors the revolution of 1848 with its humanitarian ideals and belief in progress. He never tired of expressing in his work the fight against totalitarianism, the power of money and inequalities of every kind. He never belonged to any party but was motivated entirely by idealism. His pictures are full of humour too, and make use of anecdotes and puns. Some of them are practically incomprehensible without an accompanying explanation.

When Dechelette was not painting, he was inventing — all sorts of crazy things which in any case had been invented a hundred years earlier. He poured all his savings and everything he earned from his pictures into these 'inventions'. He died poor and utterly convinced that he had completed a task of incomparable benefit to mankind.

Louis Dechelette
The Brothers Trouille, Acrobats, **1950** 46

Simon Schwartzenberg, born on September 20, 1895 in Galata (Rumania), has lived in France since 1898 and is a French citizen.

Schwartzenberg's talent is not confined to painting, but also embraces other activities, especially music. He constantly postponed the 'hour of truth', in other words his painting. But with the occupation of France that hour struck. Existential questions needed to be posed — and answered. Two of his children died in a concentration camp. He sought destruction, a narcotic for his grief, and found it in painting, which he has actively pursued since 1952. His work is full of richness, feeling and refinement. Schwartzenberg's pictures do not correspond with people's preconceived ideas about naive painting, which factor has prevented his wider acceptance. This probably accounts for his periods of dejection, when he produced nothing or very little. But nevertheless, his views of Paris show quite clearly that he is one of the great naive painters of our time.

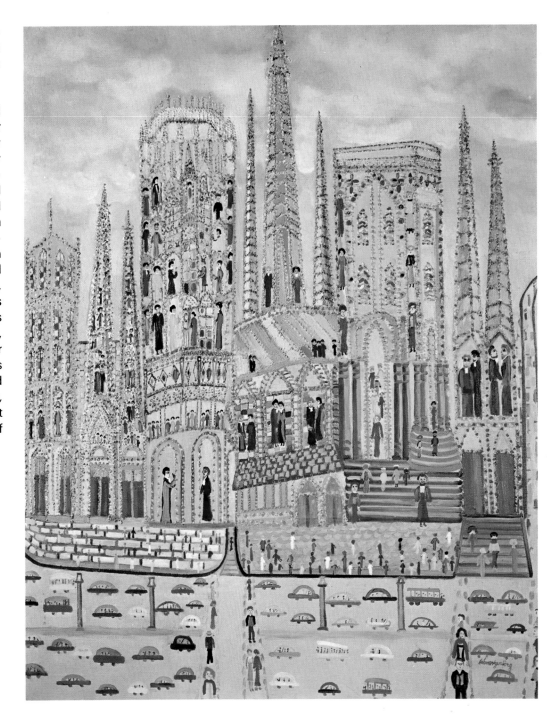

Simon Schwartzenberg
Rouen Cathedral

André Bauchant, born on April 24, 1873 in Châteaurenault, died on August 12, 1958 in Montoire (France).

Bauchant is one of the 'great five' promoted by Wilhelm Uhde between the two wars. He started to draw quite by accident during the First World War. He was a surveyor and his technical drawings caught the attention of an artillery officer, who encouraged him. By the time of the armistice he was already exhibiting in the Salon d'Automne, where he was discovered by le Corbusier and Ozenfant (who at this time were publishing the avant garde paper *L'Esprit Nouveau*, and furthered by them. Bauchant became famous overnight. In 1927 S. Diaghileff commissioned him to paint the setting for his ballet *Apollon Musagète*.

In spite of his success, Bauchant continued to work as a garden nursery man, which certainly had no detrimental effect on his painting. His most successful and sensitive works are those depicting fruits and flowers.

Bauchant was a prolific if somewhat uneven painter. This unevenness increased towards the end of his life, when he turned himself into a veritable picture factory. But even these works have authentic traces of naiveness and a certain greatness. His pictures were 'great' in a literal sense as well, for, like Rousseau, Bauchant chose to paint very large canvases. His themes are drawn from mythology or history, but rural scenes showing his native Tourraine abound as well, and are drawn with great vitality and freshness.

Bauchant is one of the few naive painters to have been awarded the Légion d'Honneur.

André Beauchant
Ships at Sunset

Lucien Vieillard was born on December 24, 1923 in Toulouse.

A civil servant and doctor of law, there was nothing in his background which in any way predestined him to be a naive painter. And yet his paintings embody the purest form of naive art it is possible to imagine. He paints with complete honesty; there is nothing forced about his work and he shows not the slightest interest in what is going on beyond the confines of his pictures. He is a newcomer but already one of the great hopes of France in this genre. He shows no ambition to fill such a role, nor has he disappointed those who believe in him: Vieillard's work is of a genuinely high quality. A particular feature of his pictures is the total absence of any life. There are neither people, animals, nor birds. But was Giorgio de Chirico any different during his metaphysical phase?

Lucien Vieillard
The Great Pavillion in Toulouse, **1975**

Vieillard has enjoyed great success and has been awarded the Pro Arte Prize of Morges (Switzerland).

Émile Blondel, born on August 6, 1893 in Le Havre, died on September 13, 1970 in Pavillon-sous-Bois near Paris.

One of Blondel's most beautiful pictures is called quite simply *My Life* and shows a large part of the French landscape. It stretches from the fields close to his home town, with a strip of coast and sailing ships in the distance, as far as the bus terminal on the edge of Paris. It should be said that Blondel was a farmer, a seaman and finally a bus driver, and he only started to paint during his retirement.

His pictures are painted with a workmanlike honesty and radiate a kind of angelic tenderness. He was a deeply devout person and considered it his mission to celebrate the beauty of life. This is borne out by his own conduct. He suffered from an incurable form of stomach cancer, but willed himself to carry on painting for another six years to bring his great work to an end. In spite of his suffering he never interrupted his labours. His pictures of sun-drenched landscapes conjure up an unending Sunday atmosphere.

Émile Blondel
Blessing the Sea

Jean Fous, born on April 9, 1901 in Paris, died in 1971 near Toulouse.

Fous was the son of a picture framer from the Quartier Saint-Germain-des-Prés. He belonged to the second 'wave' of naive painters which swept across France after the Second World War. His life demonstrates the social changes which took place during this time. Instead of taking over his father's business, he became a kind of itinerant tinker, moving from street market to street market.

Without doubt the sight of the objects washed up on the pavements of the street markets, like so much flotsam of life, moved him irresistibly to take up his brush, which he did with much affection and feeling. Many of the street markets around the gates of Paris have, unfortunately, now disappeared, to be replaced by modern buildings of steel and glass.

But thanks to the paintings of Jean Fous it is possible to catch a glimpse of what life was like in the old days.

Jean Fous
Street Market in the Rue Mouffetard, **1944**

51

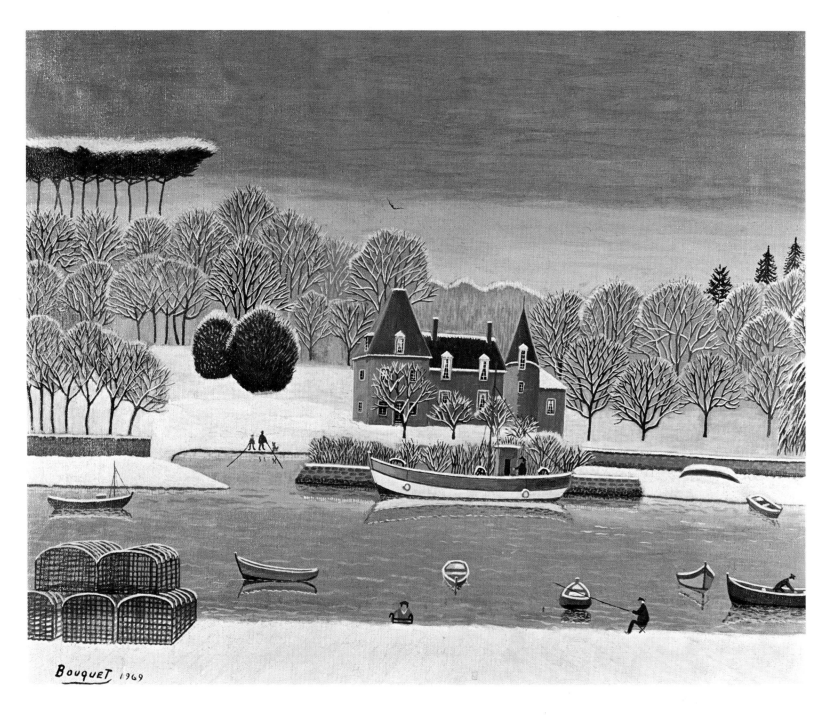

Bouquet 1969

André Bouquet
View of Villeneuve-Saint-Georges, **1969**

André Bouquet, born on September 19, 1897 in La Varenne-Saint-Hilaire, now lives in Villeneuve-Saint-Georges.

Bouquet is a travelling butcher and sausage maker by trade. Gripped by the demon of painting, he first became a cook and then a foreman in a factory, in order to have a little more time to paint. As a typical suburban dweller he has a real flair for picturing those depressing districts which are neither town nor country, where all seasons are the same, apart from winter with its blanket of dirty snow, all of which Bouquet describes with the true lyricism of a poet. He is the observer of a disappearing world, which is being replaced by the remorseless growth of the consumer society.

Nina Barka was born on October 5, 1908 in Odessa (Russia).

Her parents came from the Ukraine and were partly of French origin. She fled Russia after the October revolution, and after a lengthy stay in Constantinople, she arrived in Paris, where for a long time she managed a haute-couture fashion house.

Nina Barka is a naturalised French subject, but her work is full of Russian echoes and Byzantine archetypes and has a sensuality normally found in Persian painters. Hers is a very strange and rather formal, fairy-tale-like world, an image of a lost paradise full of luxury, peacefulness and voluptuousness. Her naked and half-naked figures exude a pervasive sensuality which make Nina Barka one of the few erotic (in the best sense of the word) naive painters.

Nina Barka
Wine Harvest

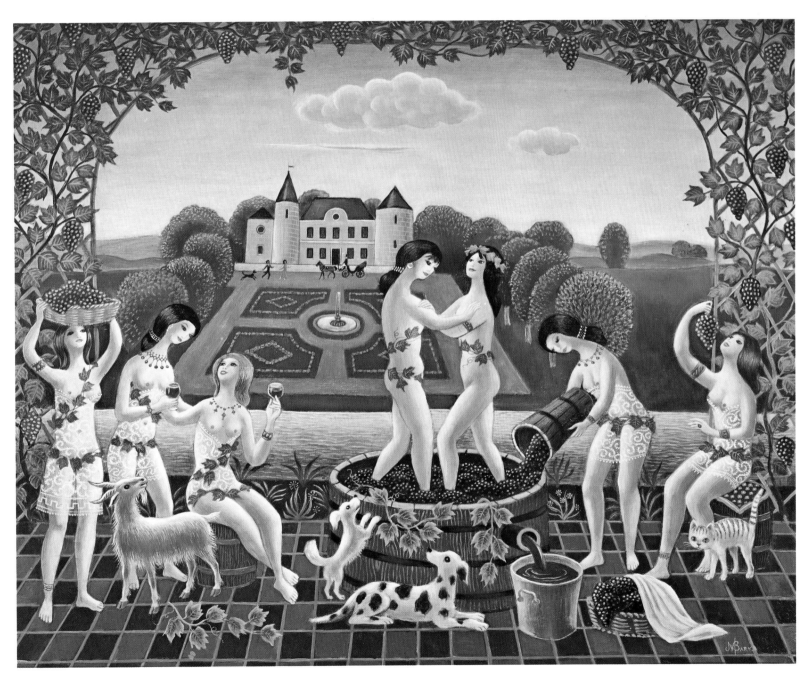

53

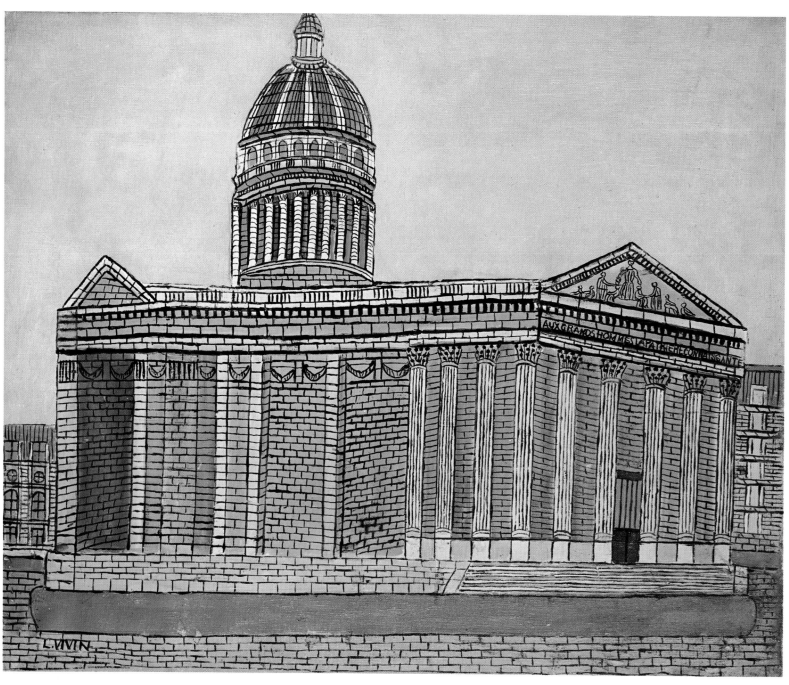

Louis Vivin
The Pantheon in Paris

Louis Vivin, born in July 1861 in Hadol (Voges mountains, France), died on May 28, 1936 in Paris.

Though alphabetically one of the last, Vivin is one of the first 'five greats' to be actively promoted by the Parisian picture dealer Wilhelm Uhde between the two wars. Uhde discovered Vivin exhibiting his pic- tures in a little street in Montmartre. Such things were still possible in those days.

Vivin was a fairly high ranking post office employee, and did not have to paint for a living. After meeting Uhde his style changed noticeably. What previously had been heavy and thick, and rather bucolic in character, suddenly became bright and clear, almost ethereal. His paintings have 54

a kind of immaterial quality. Perhaps Wilhelm Uhde introduced him to a painter like Paul Klee, to show him what was happening elsewhere in the world of painting. Perhaps the change came from that spiritualism which Vivin was increasingly beginning to manifest. We shall never know and can only admire his distinguished, aristocratic work, which ranks with the finest not just in France, but in the whole field of naive painting. The clarity of his pictures is typical of French art since the Gothic age.

Louis Vivin
Still Life

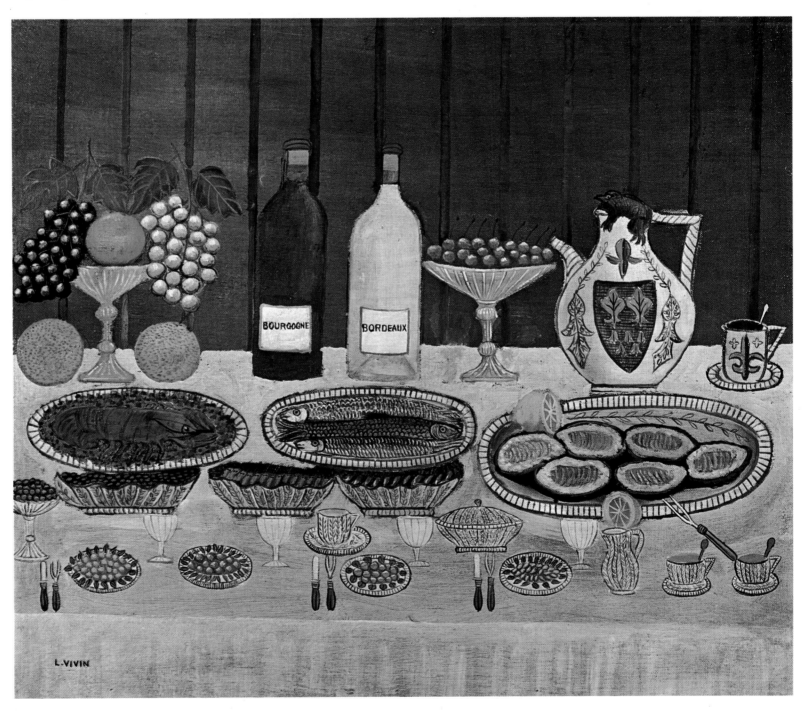

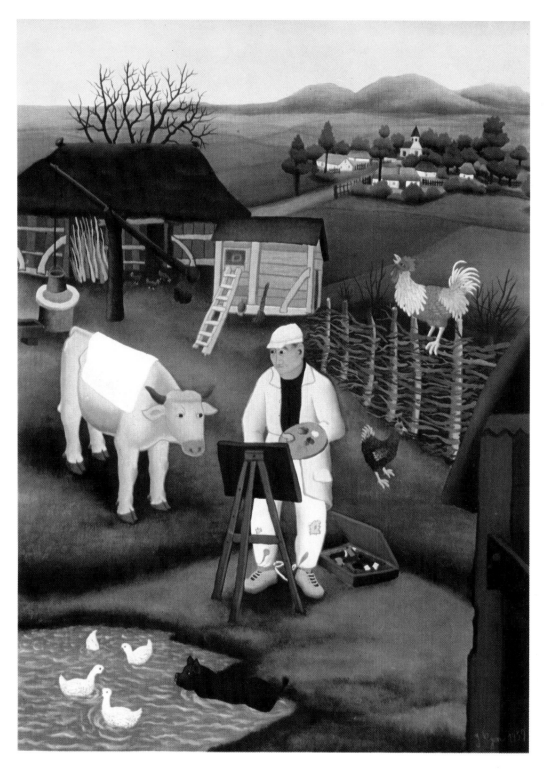

Ivan Generalič was born on December 21, 1914 in Hlebine (Yugoslavia).

Generalič is the outstanding talent within that extraordinary flowering of naive painting in Yugoslavia. He is a monument as well as a symbol, both historically and in terms of the actual graphic quality of his work. Generalič occupies a position in Yugoslavia comparable to that occupied by Rousseau in the hearts of French naive painters, by Trillhaase in that of the Germans, and by Metelli in that of the Italians.

Generalič's pictures, while observing all the rules of proportion, are reminiscent of Brueghel. This was certainly the impression created by a large show of his work within the context of an exhibition entitled 'Naivni 73'.

In spite of his fame Generalič has never left his farm, his vineyard and his fields, which he continues to cultivate as if nothing had happened. Perhaps this is why his art has kept its authenticity, its empathy with nature with its changing seasons, and its humanity, like everything that comes into contact with the earth.

Ivan Generalič
Self Portrait

Mijo Kovačič was born on August 5, 1935 in Gornja Suma (Yugoslavia).

Kovačič is a farmer and cattle breeder. If only because of his age, he belongs to the second generation of what is erroneously called 'The School of Hlebine'. Encouraged by the success of his first pictures, he has devoted more and more time to painting and has been exhibiting since 1954. He is extremely gifted and his progress has been enormous, so that he will soon rank equal with his predecessors.

His subject matter is different from that of his fellow painters, though always inspired by rural life. He shows a certain dreaminess, as well as a dramatic use of light.

Like Generalič, he has a preference for painting in the 'églomisé' manner, and his works are flawlessly executed. His success has been enormous. Even at the large international exhibition of naive painting in Milan in 1974, where every visitor was given a voting slip, Kovačič's paintings gained the highest number of votes.

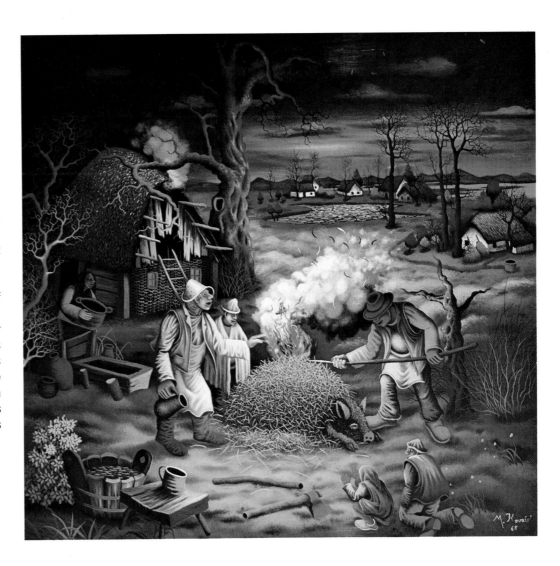

Mijo Kovačič
Singeing a Pig, **1968**

57

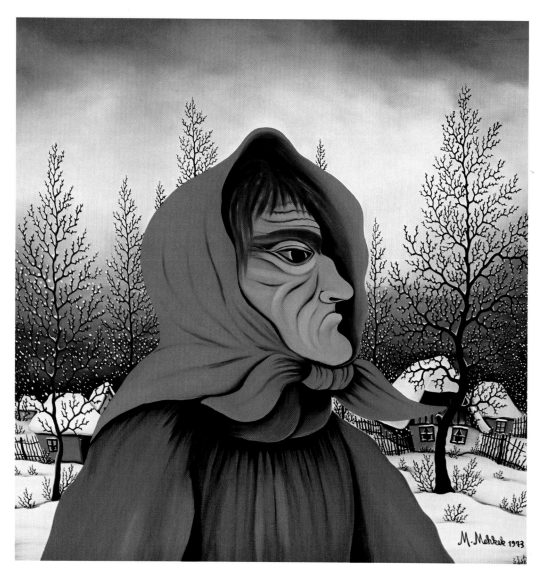

Martin Mehkek was born on August 7, 1936 in Novacka near Gola (Yugoslavia).

Mehkek has a farm close to the Hungarian border. He paints mostly during the winter when there is little work to do.

He is also a member of the 'Hlebine School' and is particularly remarkable for his heads and portraits, which are very expressive and executed as if engraved with a chisel. He draws mainly upon gypsy life for his characters, and his pictures remind one of certain medieval paintings and of works by Hieronymous Bosch. His colours are somewhat more brutal than those employed by his fellow countrymen, but the total effect is one of a certain greatness.

Martin Mehkek
Gypsy Woman

Ilija, full name Ilija Basičevič, was born in 1905 in Šid; he died in 1972 in Šid (Yugoslavia).

This painter comes from Serbia and his work is unlike that of any of his countrymen; his biography is equally unusual. His paintings became known under a different name, that of Bosilj, who was not born in Šid, but close to Niš, and not in 1905 but in 1885. What was the reason for this confusion? Perhaps because he considered himself to be the real father of the curator of the museum for naive art in Zagreb. Or perhaps, owing to his huge success, he was even accused of not being the author of his pictures. The critics found it impossible to believe that a small farmer could paint pictures of space travel and scenes from the Apocalypse in such a novel and very personal, skillfully executed and refined style. One is reminded more of cave drawings such as those at Tassili than of orthodox icons, as some of his supporters are inclined to believe. Proceedings were initiated against him, during the course of which he had to paint in public, sometimes before some well known museum curators. The result was inconclusive. Gradually all the fuss died down until, towards the end of his life, the authorship of his pictures was again questioned. This occurred at the time when a large exhibition was to have been held in Rome, which eventually did not take place: the controversy surrounding Ilija was perhaps one of the contributing factors. His painting achieved a posthumous triumph during the 'Naivni 73' exhibition in Zagreb. In view of the incomparable beauty and imaginativeness of his pictures, the question of the authorship of his work is really rather unimportant. In any case, it is too late, or perhaps too early, to say whether his paintings are counterfeits or whether he was 'manipulated', as is maintained by some people. But Ilija endures.

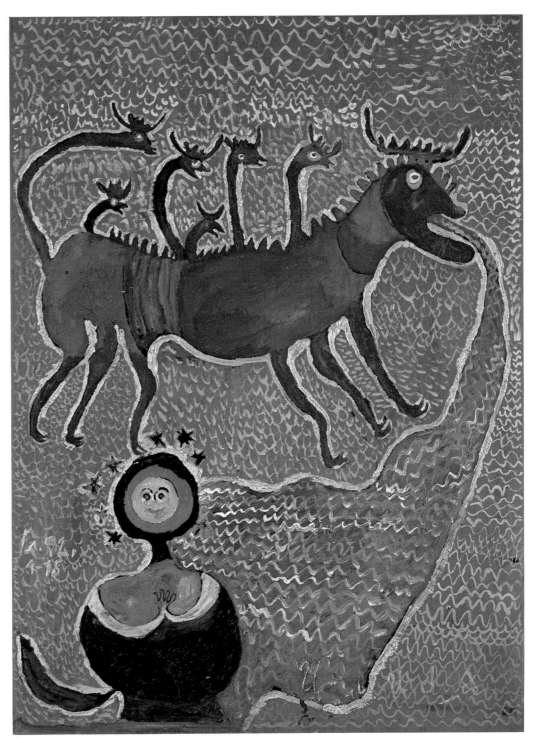

Ilija
An Apocalyptical Animal

Mato Skurjeni
A City on a River (Une Ville d'ailleurs)

Mato Skurjeni was born on December 14, 1898 in Veternica in the province of Zlotar (Yugoslavia).

Skurjeni's parents were farmers but he himself worked as a decorator and a railway employee. Although unfortunately less known outside Yugoslavia than Rabuzin and Generalič, he nevertheless should be bracketed with them, in spite of the fact that they are all very different. Skurjeni is a dreamer who dreams with open eyes. Sometimes these dreams be-come a little surrealistic, sometimes his pictures predict the future, a dark vision filled with war, destruction and con-flagration. The age of the atom bomb! It is the purest science fiction. But he paints all this with such seriousness and sincerity of belief, that even the most hardboiled sceptic is silenced. Nor can one deny his outstanding talent. Skurjeni has published portfolios of his work and illustrated a few books. He is a very good draftsman and attended evening classes to further himself in this field.

Ivan Lackovič was born on January 11, 1932 in Batinksa (Yugoslavia).

He is the youngest of the great naive painters of Yugoslavia, and he differs from them in the delicacy and transparency of his colours which allow his well structured draftsmanship to come through. His landscapes exhibit a special depth of emotion. They are flooded with a light which contributes to their higher degree of reality. Lackovič is one of the few draftsman amongst naive painters.

He gave up his job as a gardener in 1957 and moved to Zagreb, in order to be close to the Museum of Naive Painting. There he worked at the post office. He has illustrated various books and published portfolios of his drawings, which are arranged in themes, e.g. 'landscapes', 'zodiac signs', 'planets'. His work has been shown at most of the international exhibitions, and he has received a number of richly deserved prizes.

Ivan Lackovič
Red Cows

Ivan Rabuzin
The Birth of the World

Ivan Rabuzin was born in 1919 in Ključ near Novi-Marof (Yugoslavia).

Rabuzin used to be a village carpenter and became one of the greatest naive painters of all time. His unmistakable 'style' is marked by the use of blue and pink tones, and a myriad of bud-like shapes. Rabuzin is not content merely to show the surface of reality; his paintings transcend reality. He is able to do this because he is a great poet. Everyone of his pictures is a quintessence of its component parts, the

clouds, the earth, the air, trees, women and so on. Rabuzin's women are goddesses which have risen up from the very bowels of the earth, intent upon bearing fruit and multiplying mankind. They are always placed in a landscape which is a kind of Garden of Eden where animals still have the gift of talking.

Rabuzin only shows what his eye sees. The few chosen individuals who were lucky enough to be received by him, had no trouble in recognising his landscapes, with their round hills and tender tones of

orange and green, even though his brush had enchanted them.

Looking at the two pictures shown here, which in part are made up of hundreds of tiny spots of colour, one is struck by a feature common to many naive painters: a scrupulous attention to detail and carefulness of execution which made no concession to the time invested. Painting was a labour of love.

Ivan Rabuzin
Flowers and Sun

Antonin Rehak was born on January 17, 1902 in Svaty Kopecek (Czechoslovakia) where he died on April 5, 1970.

Rehak, a gardener and bee-keeper by profession, started to draw at an early age. His drawings contributed to the support of a large family during the First World War. Since then he has continued to cultivate his artistic talent and has made a name for himself as a naive painter. His view of Karlsbad, where he went in 1961 for a cure, shows his endeavour to represent reality as accurately as possible, a typical feature of naive painting. But Rehak has managed to give the town a fairyland quality, and little effort of imagination is needed to people these streets with the aristocratic patrons of a past and grander age. 'Once upon a time . . .'

Antonin Rehak
Karlsbad, **1961**

Ondrej Steberl was born on April 23, 1897 in Pezinck (Czechoslovakia).

A retired post office clerk he now lives in Bratislava. Steberl's talent already showed itself in his school days. In 1963 the painter burnt a series of about 60 watercolours, which dated back to those early years and which the National Gallery had intended to buy. He only slowly began to paint again in 1964, during his retirement, and soon achieved widespread recognition.

Steberl's subjects are frequently of a religious kind, illustrations of biblical stories. Other pictures show his native countryside, young girls and autobiographical episodes, such as his agonising time as a soldier in the First World War.

He employs a technique of strong contours, sometimes even inking in the outlines to enhance this effect, which gives his paintings a solidity reminiscent of icons and 'églomisé' technique. His pictures have no special perspective, this being suggested by arranging the various pictorial elements in the manner of a back-drop. They do not reflect the real world, but spring from a childlike imagination — he makes extensive use of flowers as ornamental and compositional elements — which lends his pictures a quality of enchantment.

Ondrej Steberl
Nude Woman in a Mountain Landscape,
1969

65

Nikifor
The Official

Nikifor, born in 1893 in Lemkowszeryzna (Poland, formerly Russia), he died in 1968 in Krynica (Poland).

Few details are known about the child-hood of Nikifor, who was both deaf and dumb. After a life as a travelling beggar, he appeared one day in Krynica, where he died. All we know about him is that his mother was also a beggar and probably a prostitute. Even his name is uncertain. He was ill all his life and suffered from tuberculosis. During one of his stays in hospital, one of the doctors gave him a paintbox containing watercolours. This simple event changed his life dramatically and he went on to become one of the greatest Polish naive painters, and perhaps the most authentic in the world. He earned his living from his small watercolours, which he sold to tourists like postcards. They were unsigned. The large letters on his pictures are meaningless, since Nikifor could neither read nor write. Initially he sold his 'postcards' very cheaply, but they were soon very much in demand, which explains the loss of quality in his pictures towards the end of his life. He became increasingly crippled and allowed himself to be helped more and more, merely adding a few brush strokes to his pictures here and there. Yet his uniquely personal vision shines through even his worst pic-tures. He quite often paints himself as someone he would like to be, a respected official, a father at the head of his family, or a bishop. One can frequently decipher the word 'malarz' — painter, on these portraits of himself in an ideal state.

The text written for him by friends and displayed on his little street stall, shows what personal circumstances nurtured his visions. 'Please help me, a poor orphan who has no shoes and no clothes. My shoes are quite broken. I have nothing to wear. I beg all of you, esteemed ladies and gentlemen, most sincerely to help me; God will reward you a hundred times over. No one need regret giving any-thing to a beggar, because he does not

steal anything, he is very peaceful and spends all his time painting. But it does not bring in enough to live on. Someone must help him. He has nothing to eat; he can't eat black bread, but only white, soft bread and something cooked. Esteemed ladies and gentlemen, now I have no more money for paint. One pound of paint costs 5 Zloty. Sometimes I have nothing to eat all day. No one gives anything — and why buy anything. I beg the esteemed public not to forget me, for I am in great need, I have no one to help me. God will reward all who think of me. Please pay for looking at the pictures.'
Nikifor, painter.

Nikifor
A Room

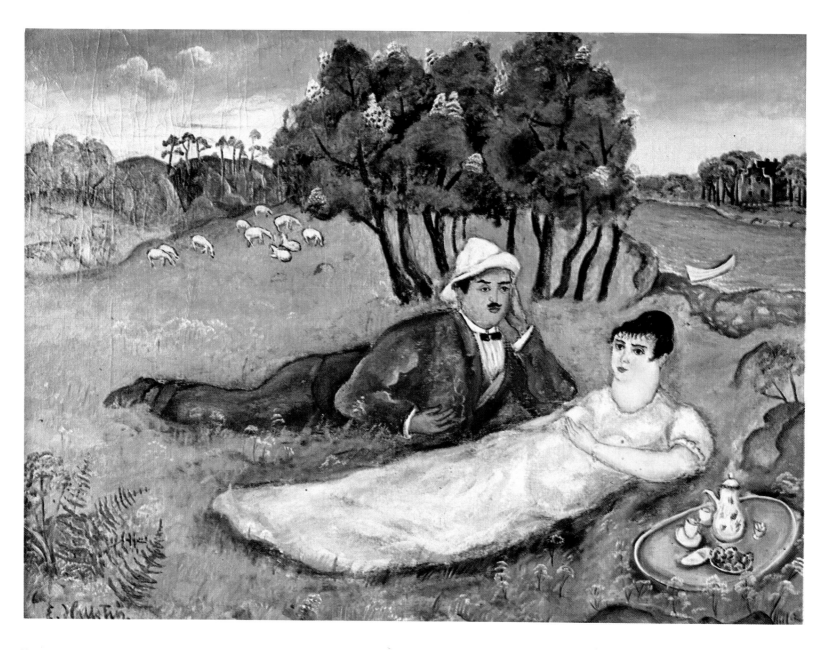

Eric Hallström
On the Island

Eric Hallström lived in Stockholm from 1893 to 1946.

Hallström's work stands on the border between naïve art and 'high' art. He was a painter by profession and for a while was close to Expressionism. His handling of colour in this picture certainly shows a professional knowledge. But his treatment of the couple having their picnic is completely naïve. Hallström, a father of nine children, and a productive painter of landscapes and views of coalmines, lumber camps and small Swedish towns, belongs to that class of painters one could describe as 'hobby' painters. Like the travelling painters of North America, he would sell his pictures on the spot. His work may be found in many private houses in Sweden, because his direct and yet poetic manner of representing everyday events corresponded to the people's need for a type of beauty they could understand.

Axel Bengtson was born in 1905 on a farm on Lake Vättern in Småland.

A farmer's son, Bengtson was first of all a teacher, then he organised an association to further adult education. He finally became the Director of the Association of Swedish Businessmen. He only started to paint in 1963 after he suffered a stroke. He was a talented story teller and upon the advice of his friends he concentrated on scenes of village and small town life in native Småland at the beginning of this century, when poverty forced many Swedes to emigrate to the United States. He painted more than five hundred pictures, usually small in format. Bengtson has captured with naive freshness the days when 'grandfather married grandmother'.

He used his organisational flair to found a collection of naive painting in the Jönköping Museum.

Axel Bengtson
Silver Wedding

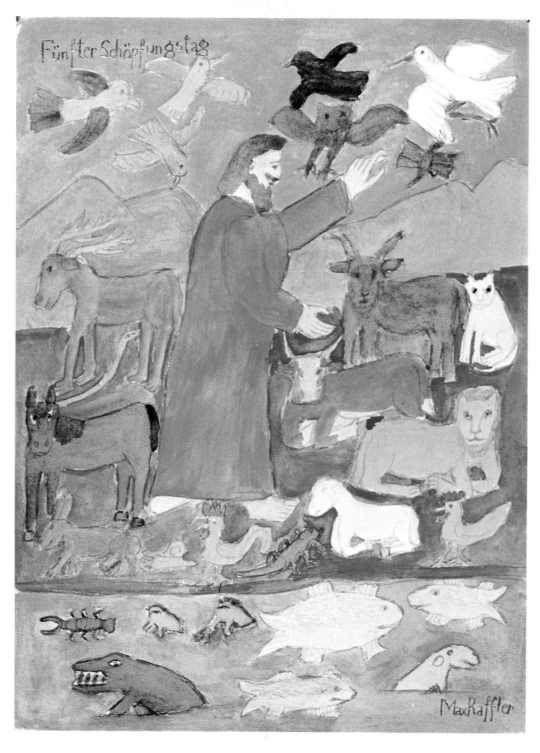

Fünfter Schöpfungstag

MaxRaffler

Max Raffler was born in 1902 in Greifenberg on the Ammersee (West Germany).

Raffler is regarded as one of the best living naive painters in Germany. But he had to wait a long time before he was able to paint. His conventional, middle class family regarded painting not only as not a profession but, much worse, as something degrading. He thus had to overcome family opposition and for twenty two years was the mayor of Ammersee.

His pictures, showing scenes of his native Bavarian landscape, and biblical stories, have the narrative quality of a fairy tale. One is constantly discovering new details in his watercolours, which are usually sketched in pencil beforehand. Many of his paintings are in the Clemens-Sels-Museum in Neuss, the most important museum of naive painting in Germany.

Max Raffler
The Fifth Day of Creation

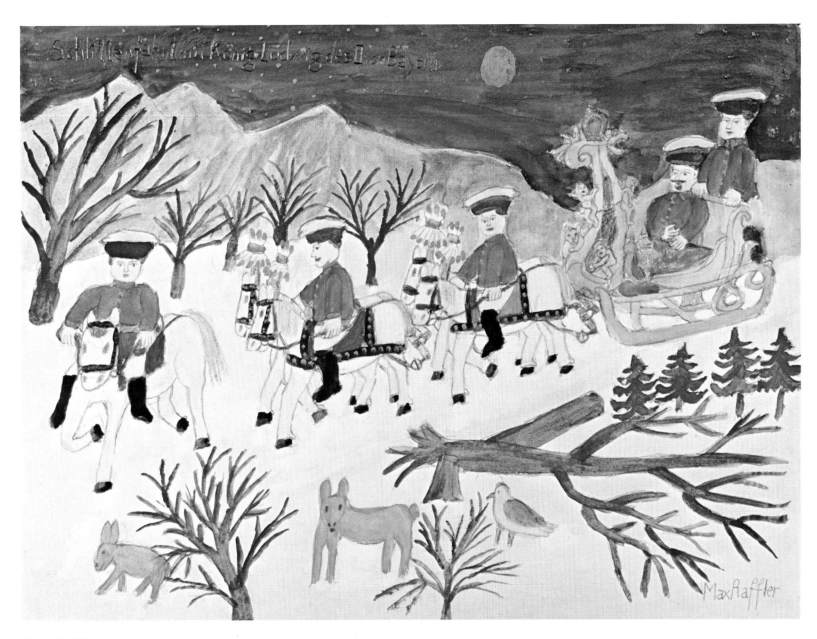

Max Raffler
A Sledging Party with King Ludwig II of
Bavaria

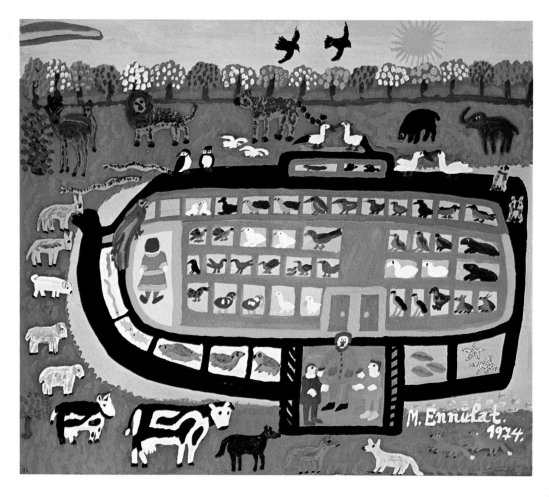

Minna Ennulat
Noah's Arc, **1974**

Minna Ennulat was born on March 19, 1901 in Baltschdorf, East Prussia.

The story of Minna Ennulat's life has the same simple and direct robustness we find in her pictures, which are mostly done in enamel paint. 'My parents were farmers. I was always hardworking and helped a lot on the farm. My mother was very pleased. She thought I was like a bee — busy from morning till night.

'In 1928 I married. My husband was chief estate inspector and I was able to help him a lot in his administrative work. We lived on the estate of Freiherr von Buddenbrock — about two thousand acres — and we had our independence. There we lived happily with our two sons until the outbreak of the Second World War. That was the end of our happiness, for my husband was called up in 1944, along with all men between the ages of 16 and 60, to dig trenches. On February 8, 1945 we had to leave. We had one hour to leave Dösen and we crossed the bay in a horse-drawn carriage in a snow storm at 28°C below zero. Before us was the front line, behind us the Russians and above us bombers and fighter-planes. Nine weeks without warm food, without sleep. In Seefeld we were quartered with the village schoolmaster. We had a small room and stayed there until the end of the summer, when my husband returned wounded and half starved from Russian captivity. It was impossible to find work or better lodgings in Holstein, so we went on to Bad Soden in the Taunus by train. We found lodgings with some relations. After much effort we were given some property in a new settlement.

'My husband was 70 and I was 61 years old. We did a lot of the building work ourselves. When everything was ready to move in we had no furniture, because we had little money and our sons were studying at university. That's when I started to paint a lampshade and some pictures because the walls were so empty. Now I am 73 and not in very good health. But I can still paint and I am very happy, because I don't have as many worries as

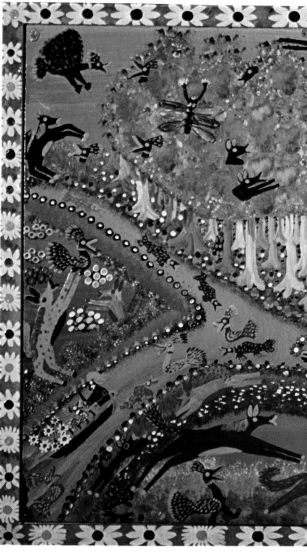

I used to, with the little money from the pension that my husband gets. I hope I shall live a few more years, because my husband is 82 and is very pleased to have a wife who is nine years younger, and so hard working.'

Many of Minna Ennulat's pictures are recollections of her native East Prussia, the animals, the old towns, comfortable farmhouses and the distant landscape. She is quite unconcerned about the rules of perspective, and exotic and native animals mingle together as if in a paradise. Her pictures, which she paints 'as busy as a bee', are genuinely original and naive.

Erich Grams was born in 1924 in Altenfelde, East Prussia; he lives in a village in the Eifel mountains.

Erich Grams comes from a large mining family, and was a miner himself, until a serious accident in 1948 forced him to retrain for another occupation. His second accident in 1964 forced Grams, the father of ten children, finally to give up work entirely. It was then that he began to paint. 'One has to be a miner to know what it means to be alive. Hours spent underground and when one comes back above ground again it is like discovering the world for the first time.'

When looking at one of his pictures one should bear in mind this statement. They are literally seething with animal and plant life. They depict a fantastic landscape in which equally fantastic animals playfully chase each other. The dreamlike colourfulness of his large picture surfaces contrasts with their dynamism, which threatens to break through the delicate order of flowers.

Erich Grams
Bears in a Field of Flowers

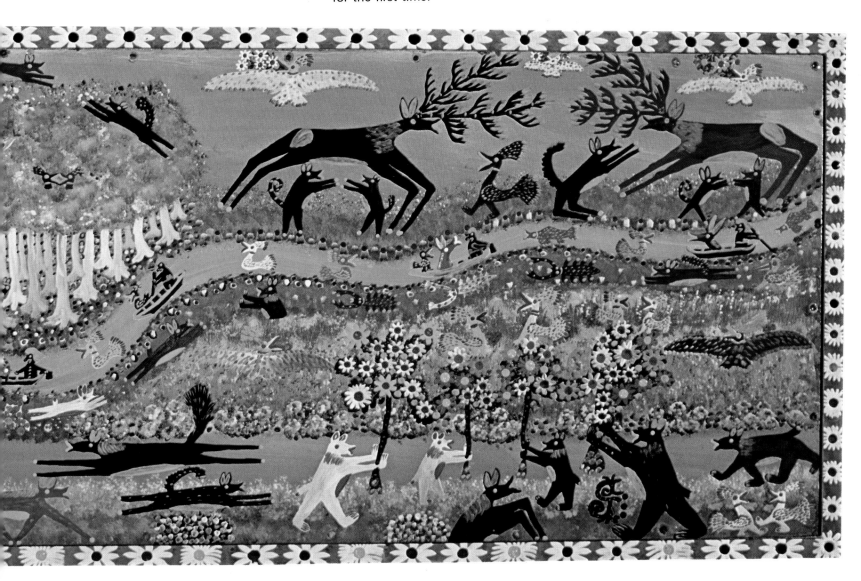

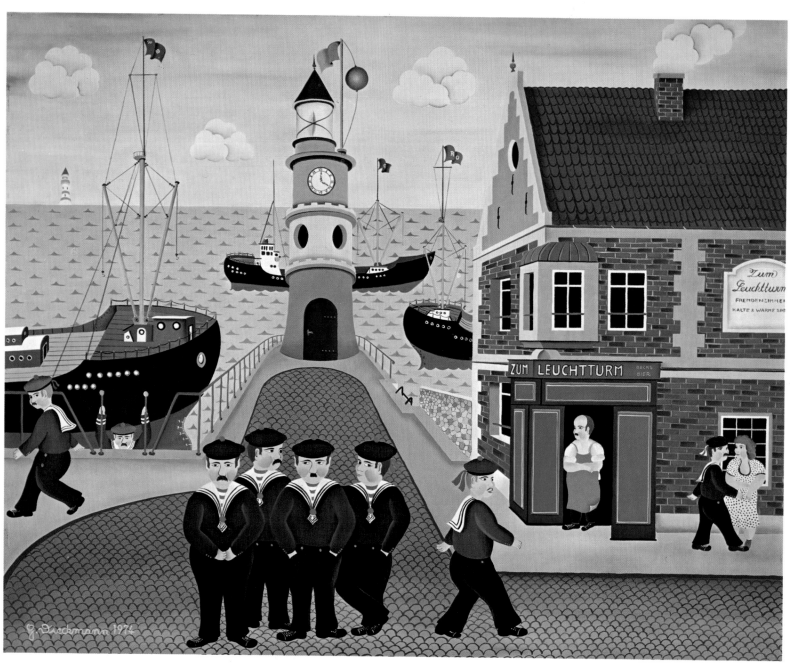

Henry Dieckmann
The Lighthouse, **1974**

Henry Dieckmann was born on June 19, 1933 in Verden on the Aller.

Dieckmann, a railway employee, has been an amateur painter since about 1968. His paintings reflect his native Northern Germany and show scenes of rural life, peasant festivals and harbour scenes. His pictures of French and particularly Parisienne life, painted while on holiday, record in great detail everything he saw going on around him. Dieckmann paints the world of the common man, sailors, farmers, provincial life, a world which is still 'intact', but already beginning to fade away. His pictures are executed with an attention to detail characteristic of so much of naive painting, and yet they have a humorous, ironic quality which is the mark of Dieckmann's work and makes this waterfront scene so attractive.

Carl-Christian Thegen, born in 1883 in Oldesloe near Lübeck, died in 1955 in Oldesloe.

Thegen started to paint in 1933, drawing on memories of his past life. Before then he had held down all sorts of jobs, amongst other things as a clown and an animal minder with the Vieux Belli and Hagenbeck circuses. He eventually owned his own circus. Conscripted during the First World War, he continued to look after horses, both on the Russian and the French fronts. After the war he drifted from job to job and even became a vagrant for a while. His painting saved him from total decline. His work is clumsy and primitive, and yet filled with a magic which reflects the longing of a man who painted the prairie with its cowboys and indians, a distant world he had never seen. His representation of animals is startlingly accurate and the graphic sincerity of his pictures is particularly eloquent. Thegen died as the result of falling out of a hayloft while he was drunk.

Carl-Christian Thegen
Girl Skipping off the Back of a Horse,
c. 1950

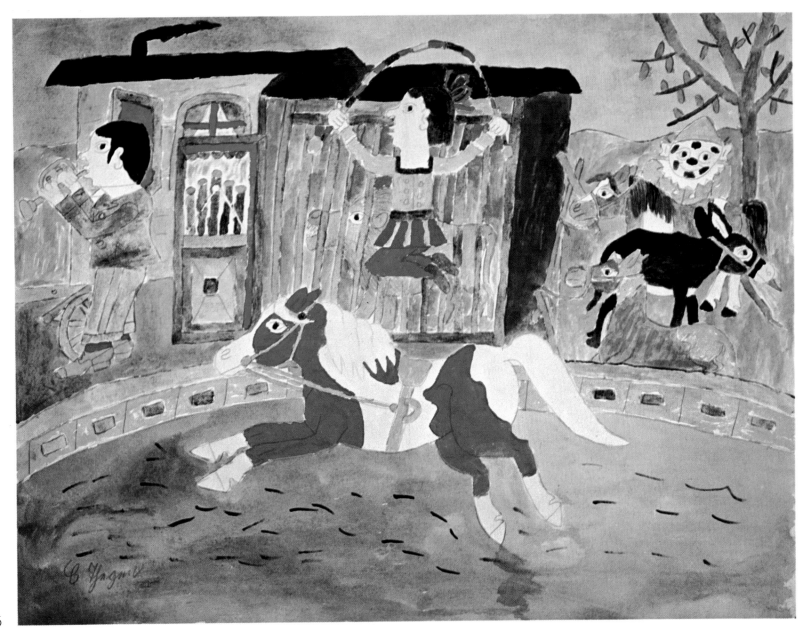

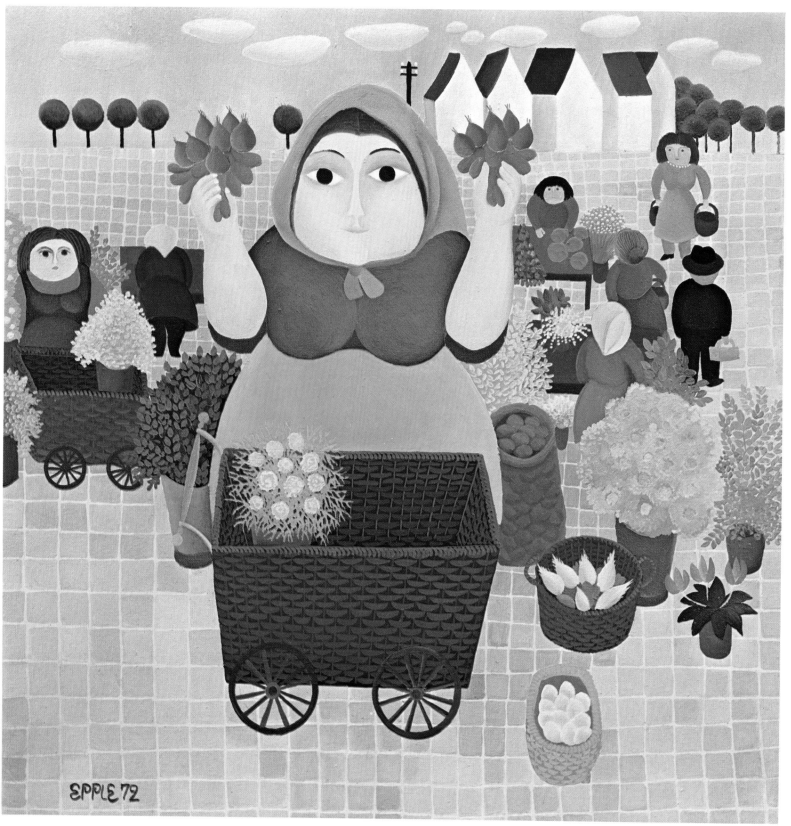

EPPLE 72

Bruno Epple was born in 1931 in Rielasingen in the Hegau (Lake Constance — Germany).

Epple lives in Wangen where he teaches German and history. He started to paint in 1955, on little pieces of wood, not to pass the time, but as a way of discovering the truth behind the perceptible world. This search has led him to paint hospital and funeral scenes, for instance, subjects which seldom appear in naive painting. He builds his pictures up slowly and carefully, using very fine brushes and several layers of paint. The result is an extremely subtle effect of shading and an exquisite delicacy of detail. Once he has discovered the truth about an object, he is no longer interested in it, and passes on to something else.

The fantastic, not to say 'deformed' quality of Epple's figures probably stems from their desire to conceal something, which only the painter can reveal. Just as the work of van den Driessche reminds one of Flemish Expressionism, so Bruno Epple's pictures — quite unconsciously — seem to echo German Expressionism. The Author of this book considers him to be the best naive painter in Germany today; a painter of international stature.

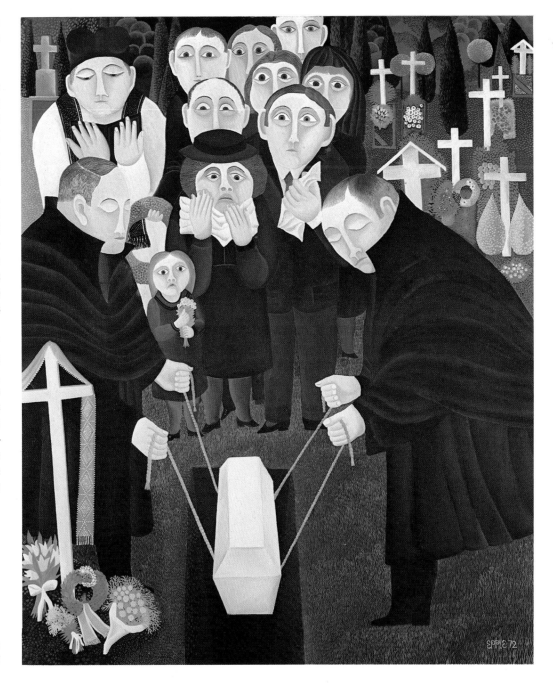

Bruno Epple
The Burial

Bruno Epple
77 *Market Woman,* **1972**

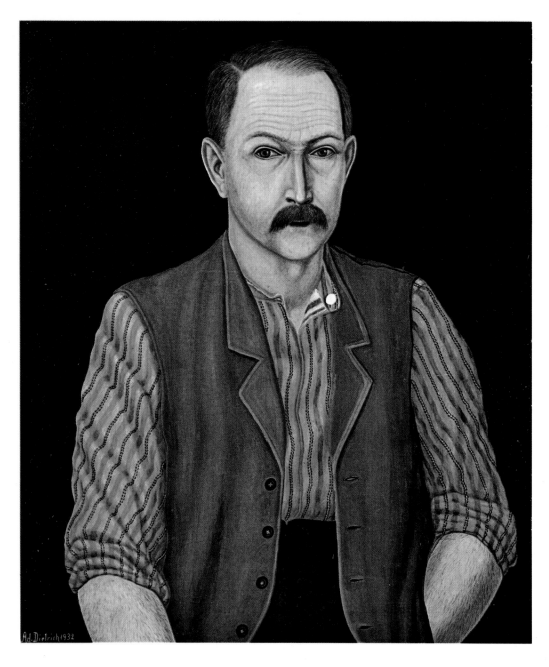

Adolf Dietrich was born on November 9, 1877 in Berlingen (Switzerland) where he died on June 4, 1957.

Dietrich, the son of a farmer, was the first Swiss naive painter to achieve international recognition. He worked in a knitting factory, as a tree feller and labourer, until, after his father's death, he turned to farming. He started to paint in 1905 and consolidated his reputation with a book of sketches called *Book of Lake Constance* (1916). Since 1927 he has devoted himself almost exclusively to painting.

Dietrich's paintings, like this self portrait, reveal his farming background. They are extremely realistic and truthful, but imbued with deep feeling and an awareness of nature. Extraordinary is the way in which his technique, reminiscent of the paintings of old masters, combines with his deeply naive and unspoiled vision of the world.

Adolf Dietrich
Self Portrait, **1932**

Adalbert Trillhaase, born in 1858 in Erfurt, died in 1936 in Niederdollendorf near Königswinter.

Trillhaase has long been considered to be the greatest German naive painter, which is not solely due to his age. It was a factor which worked against him rather than for him, because when he started to paint shortly after the First World War, a great deal of courage was needed to paint naively, especially as the public was quite unprepared.

Luckily he was able to bide his time, for he came from a well-to-do middle class family who, admittedly, would have preferred him to choose a more conventional career. But after a relatively short period of six years he was already able to exhibit his paintings in Düsseldorf with some considerable success. In 1933 the Nazis pronounced his work to be 'degenerate'. His daughter was able to save his pictures by secretly bringing them out of Germany into Switzerland.

Trillhaase's pictures draw a great deal of inspiration from the bible; stylistically they are in the tradition of votive pictures of the late Middle Ages, and often show a dash of lively expressionism so characteristic of a painter like Grünewald. The Clemens-Sels-Museum in Neuss has a good selection of his rich, varied and essentially very personal work.

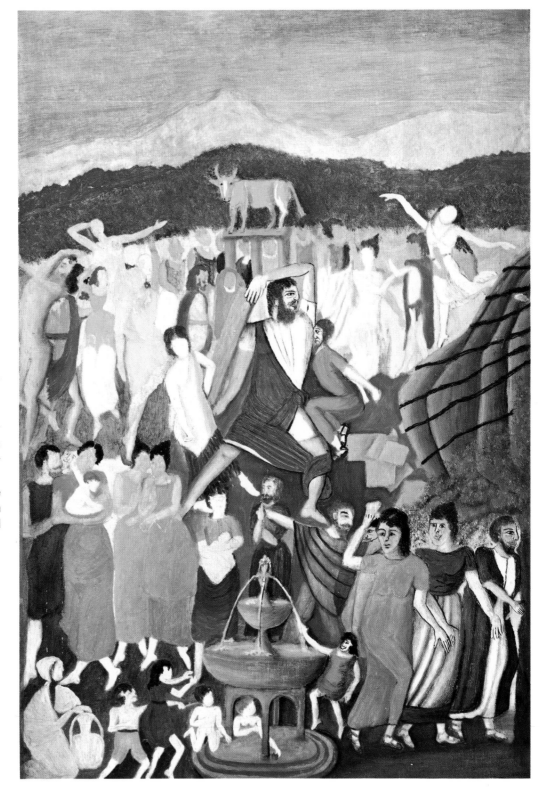

Adalbert Trillhaase
Adoration of the Golden Calf

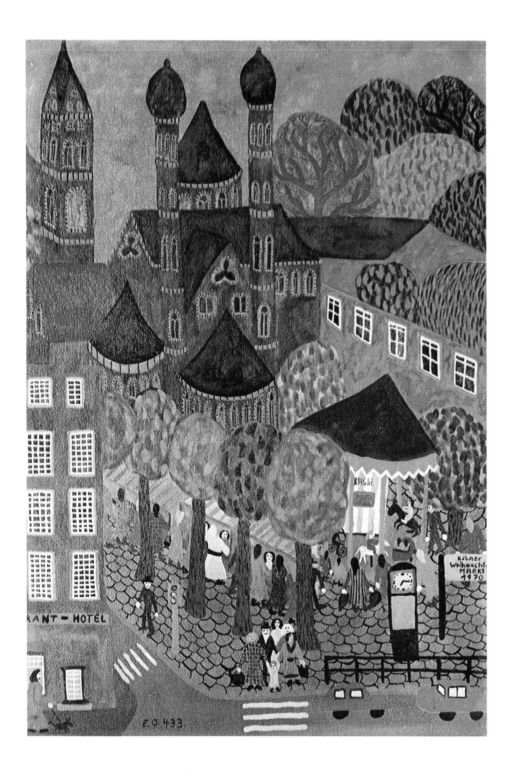

Eduard Odenthal was born on October 27, 1929 in Cologne.

Odenthal belongs to that enthusiastic post war generation of naive painters, freed from all complexes about their art. He paints what he sees with spontaneity, joy and candour. This candour, unthinkable to his guilt-ridden, naive predecessors, also comes out in his writings. His manner of painting is direct, fresh, openhearted and honest — as clear as a bird song. Perhaps this shows how an increased public understanding can lend wings even to Naive Art.

Eduard Odenthal
Christmas Market in Cologne

Leonardus A. J. Neervoort was born on February 20, 1908 in The Hague.

Neervoort, an employee with the state printing office, has only been painting since 1957. But he soon became the most popular naive painter in his country. He started to paint after a severe attack of spinal polio. Painting became his refuge, a way of justifying his existence, and allowed him henceforth to withdraw from the cares of everyday life. He was a convinced monarchist and liked to paint official ceremonies showing the royal family. His naiveness is of a very pure and refined kind, and shows once again that a naive painter has to work hard to realise his gift. He won first prize at the second Triennale in Bratislava.

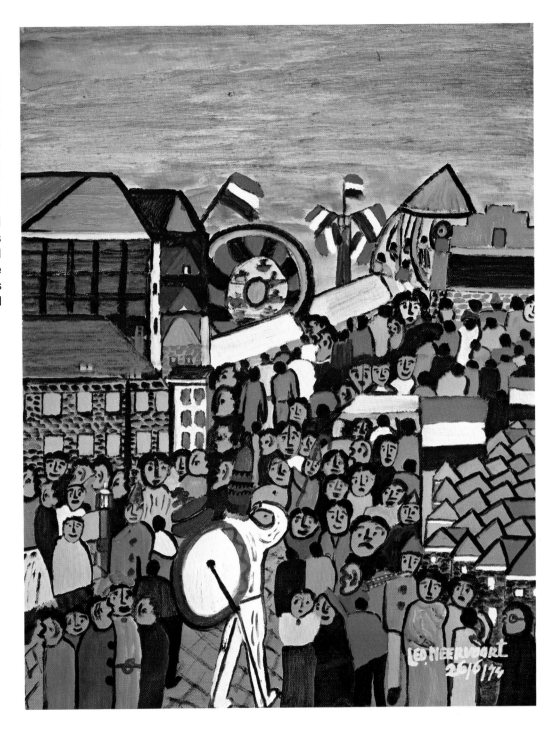

Leonardus Neervoort
The Fairground Musician, **1974**

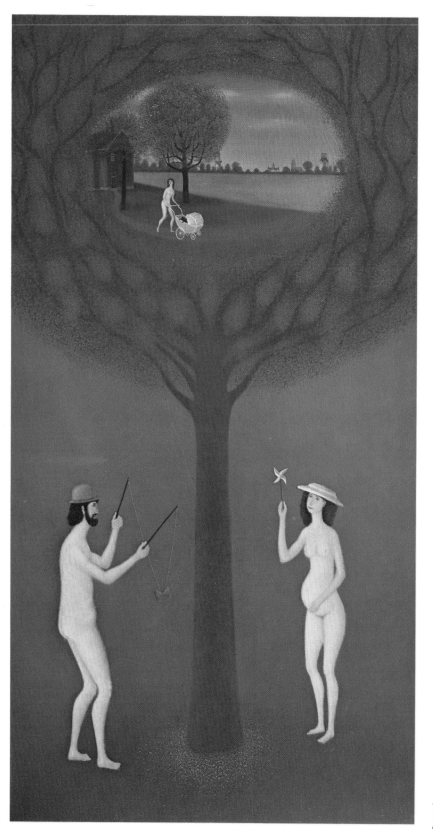

Willem Westbroek was born on December 21, 1918 in Rotterdam.

What a strange painter! He started life as a farmer, then worked as a coppersmith in a marine workshop, and finally as a manufacturer of coloured glassware. Probably this climbing of the social ladder involved a good deal of repression on his part which in turn revealed itself in his pictures.

As a rule they represent dream states, consisting usually of two groups of people, clothed and unclothed. They are reminiscent of paintings by Delvaux, though it would be an exaggeration to speak of a similarity. Westbroek is a 'dreamy' painter in the truest sense of the word, and he brings a certain scurrilous sense of humour to his work, as in this variation on the theme of Adam and Eve.

Willem Westbroek
Homo Ludens

Pieter Hagoort was born in 1887 in Grootebroek, Holland.

Hagoort was a conductor on a horse-drawn tram for many years. In 1952 he retired, but only started to paint in 1960. His paintings are very naive, almost child-like, of a charming purity and freshness only children seem to possess. But while the bright glow reflected in the drawings and watercolours of children may soon be extinguished, this light can burn on in some adults who have preserved their innocence and whose work is nourished by the experience of a life-time. Hagoort is a painter blessed with this child-like gift. This picture showing his beloved horse tramway reveals very clearly the purity of his naive vision infused with the wisdom of old age. Hopefully he will continue to paint for a long time, to please himself, of course, but also to delight us. He was awarded first prize at the 'Naivni 70' exhibition in Zagreb.

Pieter Hagoort
Self Portrait with Horse Tramway

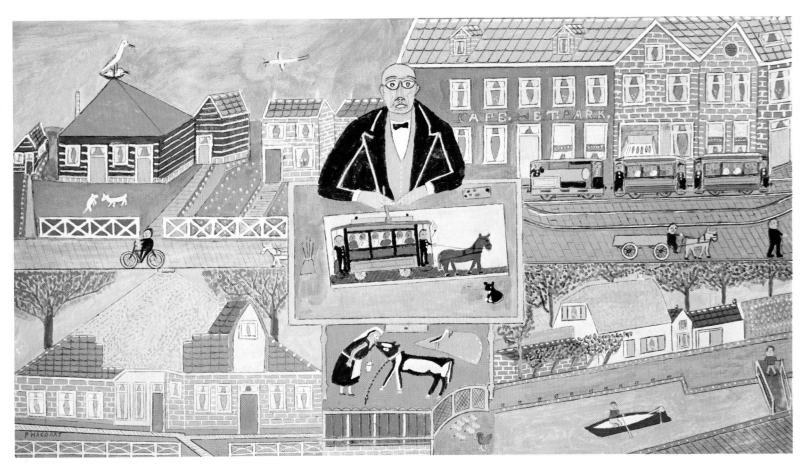

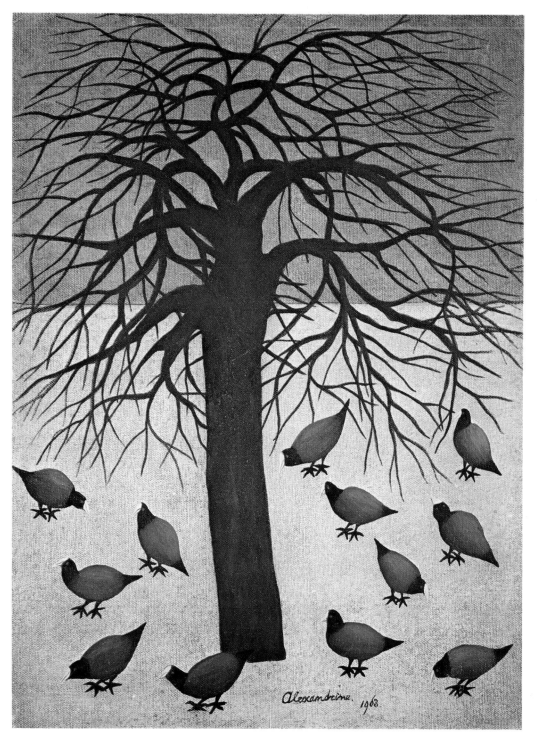

Alexandrine, whose proper name is Alexandrine Gortmans, was born on July 31, 1903 in Djokjakarta (Java). She is the widow of the painter and sculptor Toon Kelder, and now lives in The Hague.

Like so many women naive painters, she first of all brought up her children before she started to paint. Initially she concentrated on the landscapes remembered

Alexandrine
La basse-cour, **1963**

from her childhood, scenes which may seem exotic to us, but for Alexandrine were part of everyday life. There were elephants, tigers and large snakes painted against a fairy tale background, rather in the manner which European painters would use to show their domestic animals. For this reason many believe her to be an imitator of Rousseau. This is quite wrong! She never knew Rousseau, apart from which, at closer inspection, her pictures reveal quite fundamental differences, mainly in her brush strokes, perspective and use of colour. On the other hand, it shows to what extent Rousseau really 'saw' these countries, although he never left France. The plants and bushes of the Botanical Garden were all he needed to create a jungle *par excellence*.

Similarly, the few pictures of Paris by Alexandrine are the products of her imagination, for she had never visited the city.

Eye trouble has now forced her to produce mainly large coloured drawings of a remarkable delicacy and sensitivity.

Alexandrine
My Child, **1965**

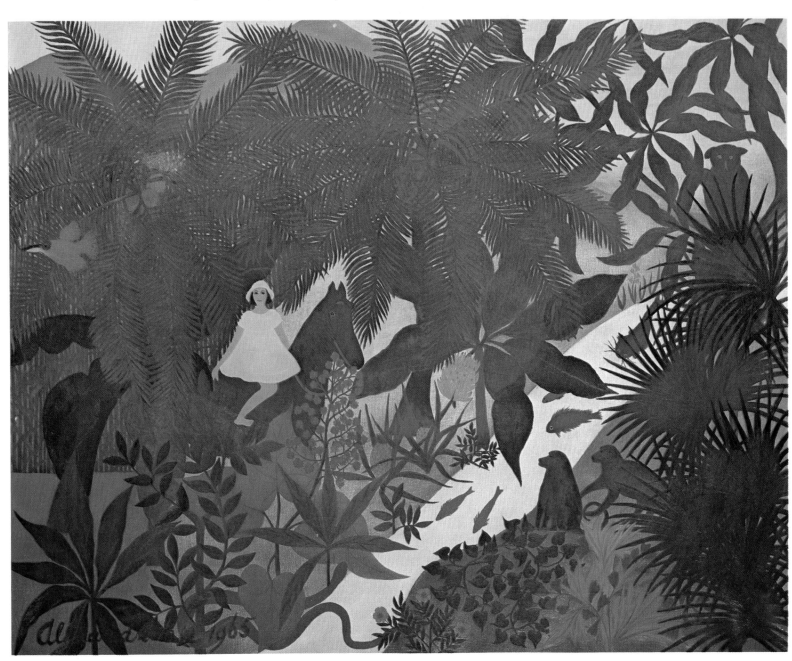

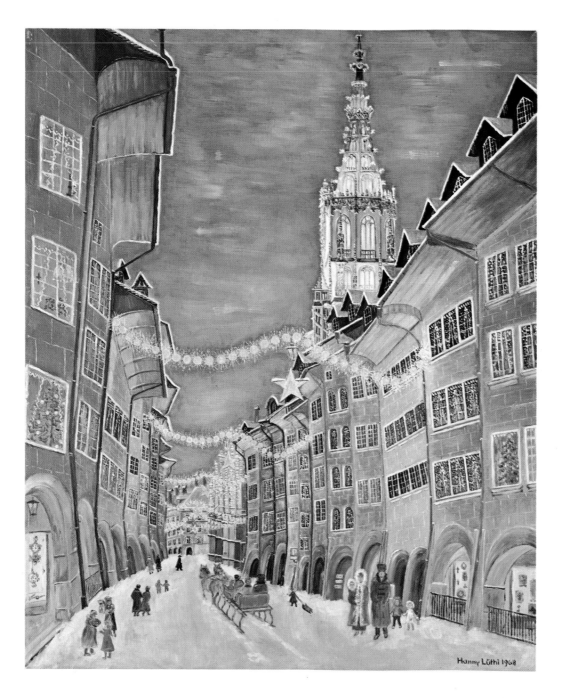

Hanny Lüthi
Christmas in Bern, **1968**

Hanny Lüthi was born on January 4, 1919 in Meiringen (Switzerland).

Looking at pictures of Hanny Lüthi is like looking into a magic mirror. One feels one is seeing the world with the eyes of a child, and can only wonder at what is revealed. Everything is infused with that transparent light so familiar from child-hood and treasured in a small corner of one's heart. Everything is fresh, clean and new, as if one were seeing and experiencing for the first time. With a single stroke of her brush Hanny Lüthi can capture the magic which lies over all things and awakens long-forgotten feelings. Looking at one of her pictures one can hear the crunching snow in the streets of Bern and

feel the biting cold on cheeks and ears. Her landscapes seem to emit the scent of freshly cut grass. One takes delight in the overabundant colour of the flower-bed, and only notices subconsciously that the trees have no leaves. Perhaps the painter was attracted by the filigree of the branches. One can smile at the old couple sitting on the bench in the garden, and the old car in the garage seems to complement the scene so well. One is a little surprised to see a stepladder, which appears to be rather 'pointless', and yet as important to the picture as a whole as the delightfully crooked shape of the house and the blue flowerbush. The picture enchants us and makes us happy. Such art cannot be learnt or imitated, it is a gift, if not a favour, bestowed on only a few.

Hanny Lüthi is without doubt the best Swiss naive painter. Her pictures are uniquely personal and therefore difficult to classify.

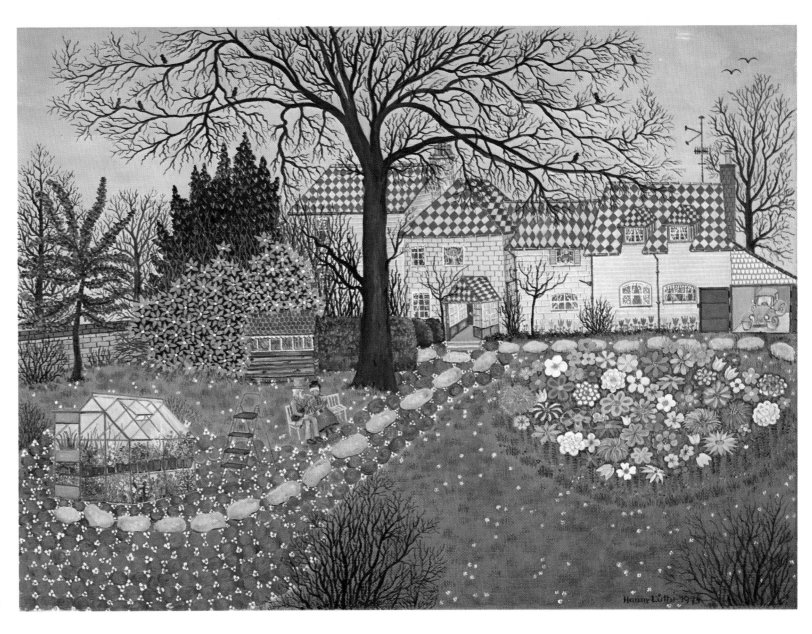

Hanny Lüthi
The Pleasures of Country Life, **1974**

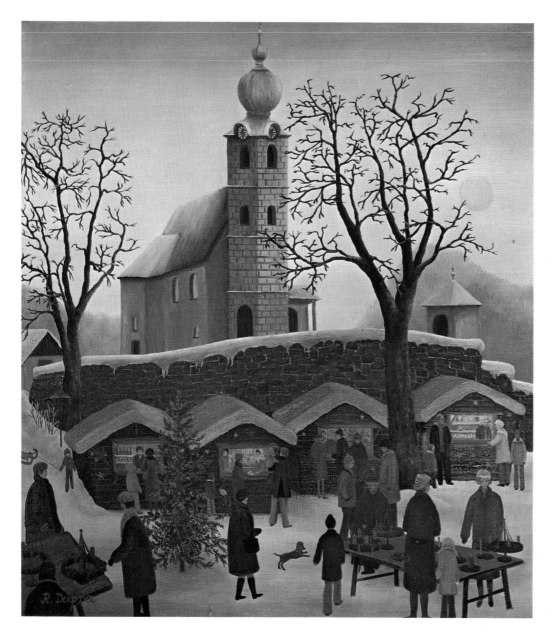

Regine Dapra, born on February 2, 1929 in Bad Hofgastein, Austria, is now living in Salzburg and working as a musician.

Regine Dapra only started to paint in 1960 after an extensive period abroad pursuing a career as a concert pianist. Her husband, a photographer, encouraged her and advised her to concentrate on painting picturesque parts of Salzburg. Her pictures have a lightness of touch, an air of elegance and playfulness, and the mildly baroque decorative elements seem to be a natural, even obvious homage to Mozart.

Regine Dapra has had a number of one-man exhibitions of her work and has illustrated various books on Salzburg.

Regine Dapra
Christmas Candle Market

Siegfried Kratochwil, born on March 24, 1916 in Karlsstift, Austria, now lives in Vienna.

Kratochwil is a goldsmith by profession which, curiously enough, comes out in his pictures. Whether he paints the Danube, an interior, or a race track, his work has a certain engraved quality, and his colours are set like precious stones into the background of his pictures, a technique, incidentally, not to be found in any other naive painter. Kratochwil paints in a very personal manner, the result of great assiduity and conscientiousness. His pictures are full of the rustic magic of a bygone age. At the moment Kratochwil is producing very little work and only paints when the mood takes him. He is waiting for his retirement, which he intends to devote entirely to painting, something he has been looking forward to all his life.

Siegfried Kratochwil
The Cabbage Cutters

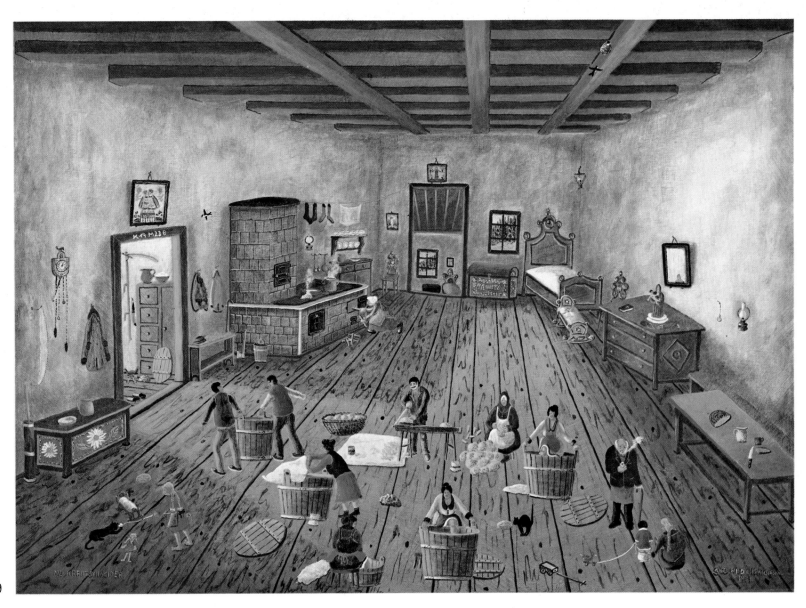

Berthe Coulon was born on December 15, 1897 in Brussels.

Berthe Coulon, a talented musician, only started to paint when she was 70. Like all naive painters, she presents a uniquely individual picture of the world. Crowds are a recurring theme of her work; one is reminded of a poem by Verhaeren, a countryman of hers, who predicted the violent incursion of the masses into a still bucolic world. This picture captures the sinister and slightly threatening nature of crowds, especially when seen from a distance, and the regression of the individual into anonymity.

Berthe Coulon rapidly established an enviable position for herself amongst Belgian Naives. She took part in one of the most beautiful exhibitions of naive painting ever held which took place in the Rotonda of Besana.

Berthe Coulon
Spectators, 1972

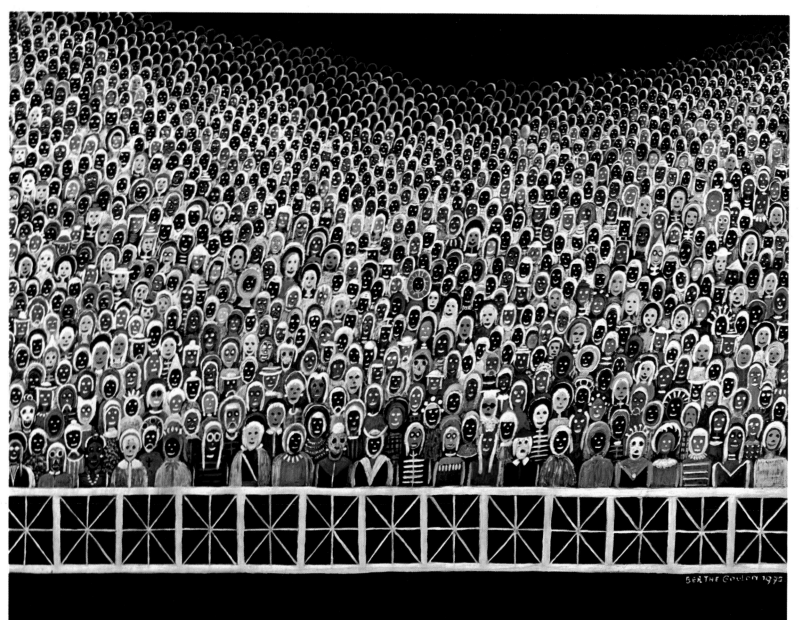

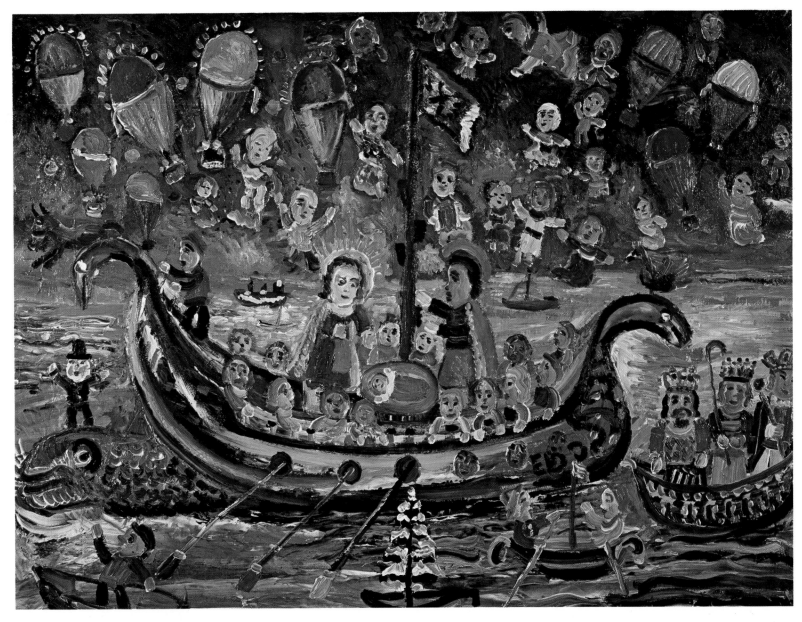

Ernest van den Driessche was born on December 25, 1894 in Audenarde.

Van den Driessche worked as a carpenter's assistant, as an apprentice painter, cabinet maker, and then became the owner of a large butcher's shop in Brussels. After the Second World War he returned to his home town and opened an antique shop. During his leisure periods — of which, of course, there are many in a small town — he painted. His pictures are inspired by Flemish folk-lore, which explains the masks, processions and giants. Their expressionist character is no accident, though van den Driessche was not personally indebted to anyone for this; it seems to be innate. One might almost talk of van den Driessche as a kind of James Ensor in the 'rough stage'. But his temperament and unbridled imagination are in no way inferior to that of James Ensor. His pictures, like those of so many naive painters have nothing aggressive about them; on the contrary, they are gay, well-balanced and exude happiness.

Ernest van den Driessche
Christmas Procession of Ships

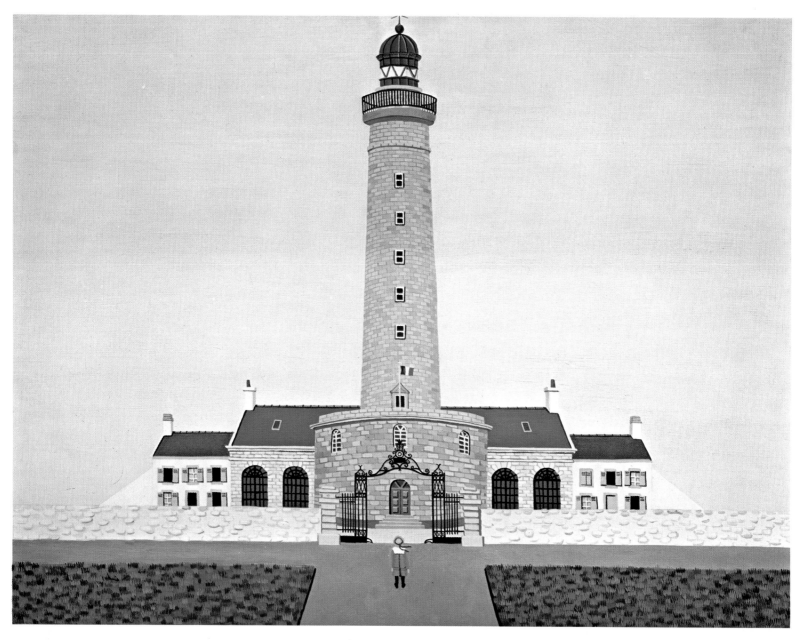

Micheline Boyadjian
The Lighthouse of Belle-Île-en-Mer, **1965**

Micheline Boyadjian, née Evrard; born April 27, 1923 in Brügge, Belgium.

Until her marriage to a well-known Brussels cardiologist, she worked as a secretary. There are some malicious people who insist that it is impossible to paint 'naively' once one has reached a certain social position. Genuine naive painters are only found amongst the people and thus, in a certain sense, are uncultivated. This view

is mistaken and Micheline Boyadjian is living proof of this.

Another accusation levelled at her is that she paints too well. Her talent, in other words, is treated with contempt, because it does not show that naive awkwardness which some people believe to be the hallmark of naive painting. However, Micheline is self-taught and cannot help the fact that she has talent, a talent incidentally which places her firmly amongst the great painters of Belgium, 92

in the same way that Rousseau has been compared to Gauguin.

Her pictures have a veracity and show a love of detail shared by so many naive paintings. At first sight there is something cold, almost aggressive about them. But then one notices the small cat in the door. We can see it walking across to rub itself against the legs of the little unhappy girl waiting on the chair, and already the bareness of the room comes alive. The picture of the lighthouse has the same effect. Suddenly one notices the little boy in front of the lighthouse and one is forced to smile. One is touched by the painter's sudden flash of humour and one feels that these pictures, too, have that 'once upon a time . . .' mystery of a fairytale.

She found international recognition during the 'Naivni 70' exhibition, which was followed by a show of her work in Hlebine, the cradle of Yugoslav naive art.

Micheline Boyadjian
Girl in a Room, **1969**

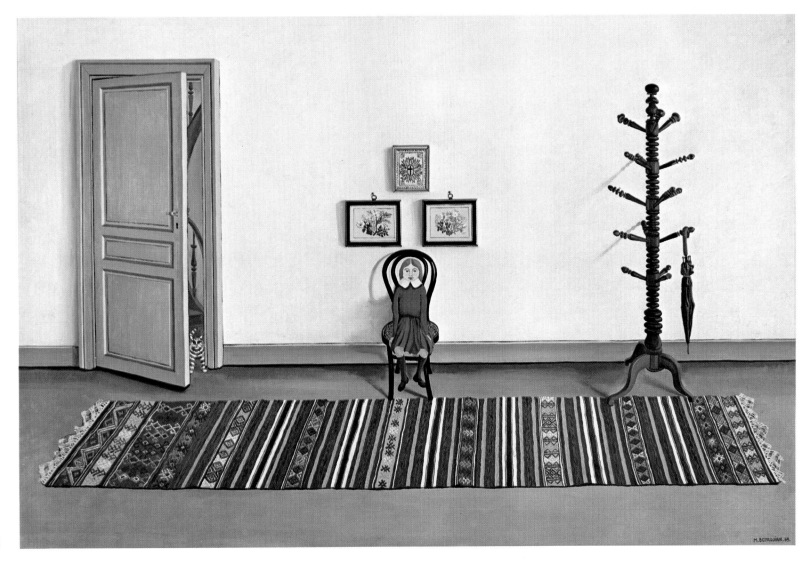

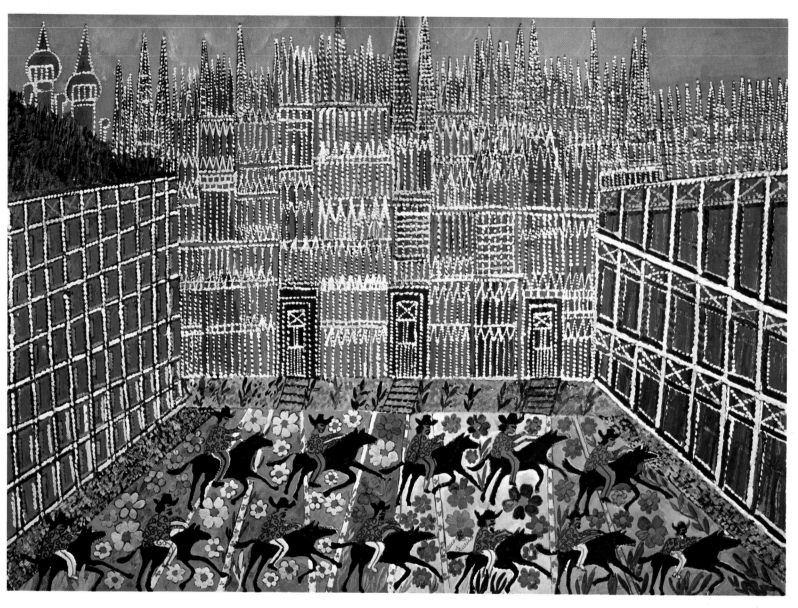

Enrico Benassi
Piazza Milanese

Enrico Benassi, born on May 14, 1902 in Casale di Mezzani, near Palermo, now lives in Parma.

Benassi, the father of twelve children has had a variety of jobs to support his family. His last occupation was that of a travelling cloth salesman. Like every true son of Parma—after all the town has given the world Verdi and Toscanini — he sang in his rare moments of leisure, mostly opera arias, of course. He started to paint around 1957 and his painting, probably quite

unconsciously, fell very much under this operatic spell. It became fairy-like, decorative and tuneful, without taking any account of time or place. His *Piazza Milanese*, with its little riders on horseback, looks like a design for stage scenery. This 'bel canto' style, which is more developed in Italy than elsewhere, has made Benassi one of the best Italian naive painters; he is certainly the most original.

His talent was rewarded with the silver medal at the 1975 Pro Arte competition in Morges, Switzerland.

Udo Toniato was born on November 15, 1930 in Borgoforte, Italy.

Toniato lives in Guastalla on the Po river, very close to Luzzara, where the well-known film director Cesare Zavattini has his villa. Zavattini founded the first museum for naive art in Luzzara. The village he used for his film *Don Camillo and Peppone* is also not very far away. Perhaps this has contributed a little to Toniato's style, for his pictures have a certain mocking and comic quality. But at the same time they are full of amiability and child-like provocation. In truth, Toniato is one of the last great story-tellers so familiar in the Middle Ages, when they celebrated the powerful and mighty in both song and word, frequently with considerable candour. Toniato's priests and politicians as well as those in power, are treated with a candour which does not refrain from ridicule. His talent for telling a story is seldom met with in a painter these days.

Udo Toniato
Policeman Chasing Thieves, **1974**

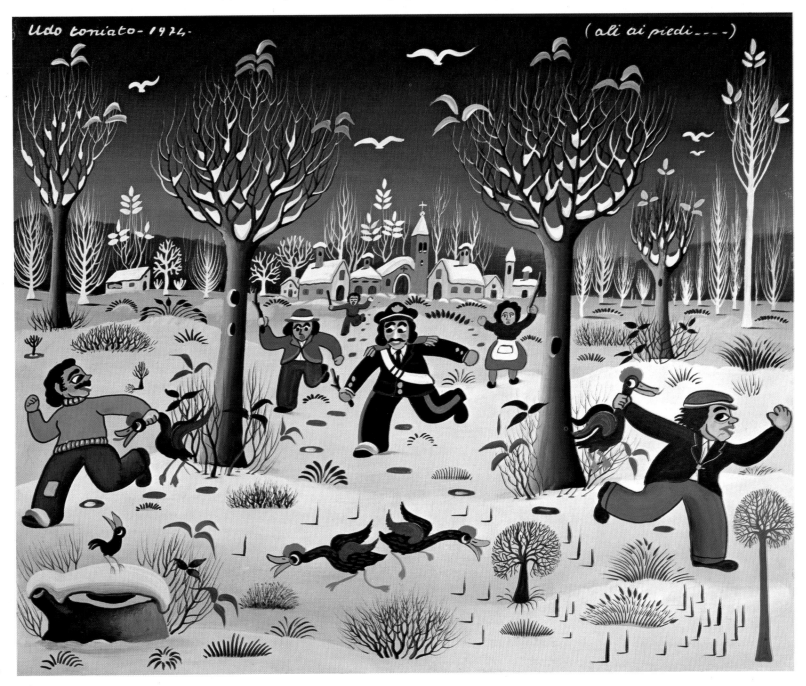

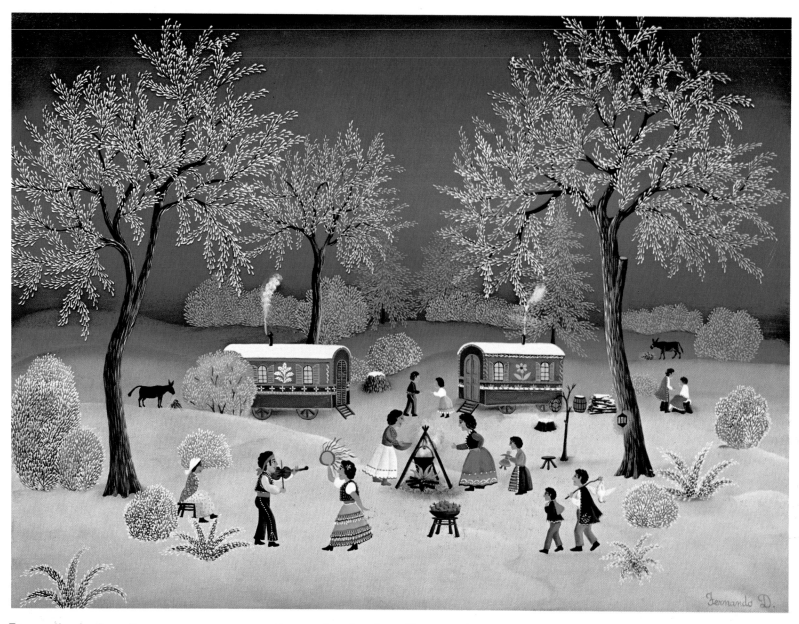

Fernando de Angelis
Gypsies in Winter

Fernando de Angelis was born on December 27, 1931 in Turin.

This painter signs his pictures Fernando D., no doubt to avoid confusion with another de Angelis, a hairdresser from Ischia.

The son of Sicilian parents, he can be considered the foremost representative of that group of very active naive painters who have gathered around Lorenzo Prato. Most of de Angelis's pictures are rather idealised representations of nature, full of purity and clarity and flooded with sunlight — a true ecological contribution. He is also very fond of the sea in all its moods, and he has painted marvellous fishing scenes, which one could use to illustrate a *Moby Dick* edition. His pictures, be they landscapes, seascapes or the rather original idea of painting gypsies in a snow scene, radiate health and an irrepressible love of life. His many ways of expressing feeling are always convincing.

Primo Berganton was born on October 31, 1895 in Bottrighe (Piedmont).

This humble hairdresser, now retired and in bad health, is not only the patriarch of Italian naive painting but one of its most noble and original representatives. As yet, he has not received the recognition he deserves. The credit of finally having discovered Berganton must go to L. Prato, the founder of a group of naive painters in Turin. But unfortunately this discovery came much too late.

Berganton's 'studio', consists of one square yard of balcony on the sixth floor of a block of flats in a suburb of Turin. Here he recreates his vision of a fairy tale city made up of those blues and reds which are the hallmark of his pictures. They represent wonderful miniatures of feeling.

Primo Berganton
Vision of Turin

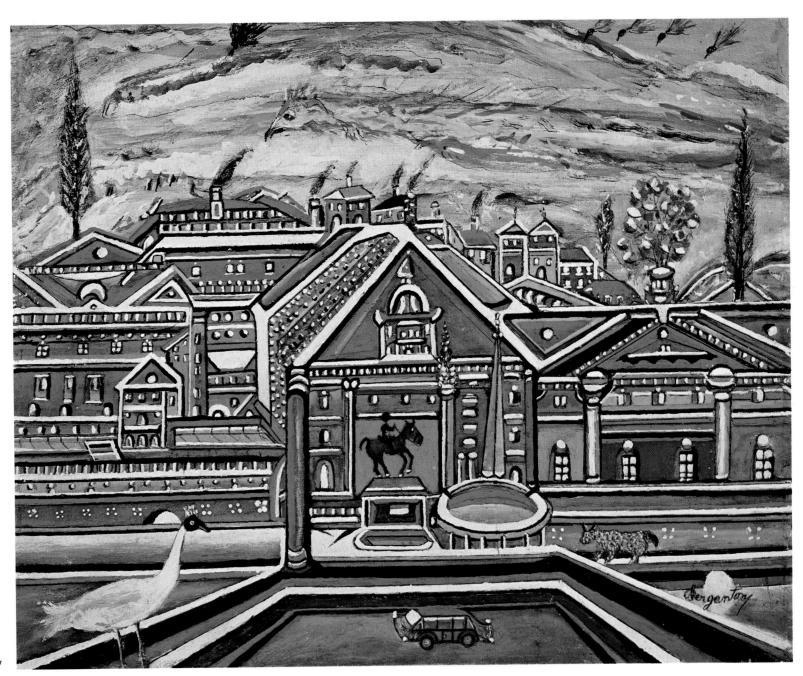

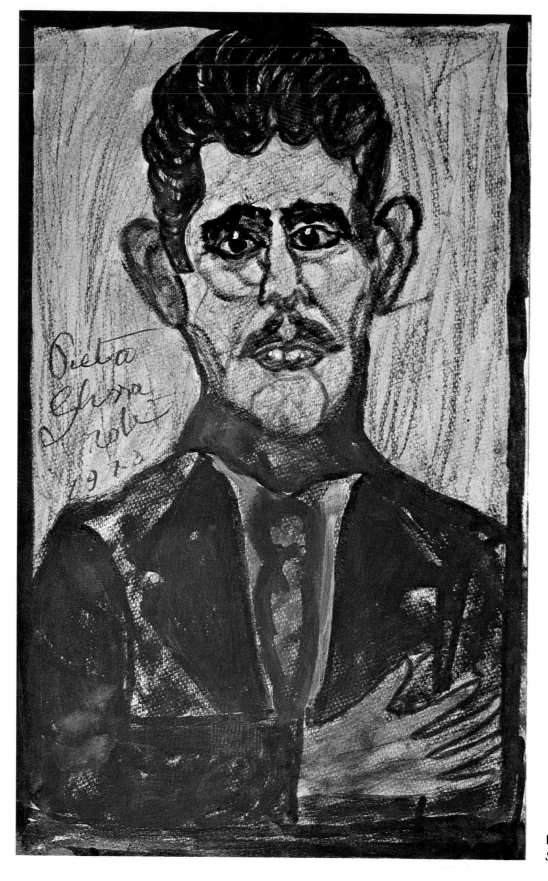

Pietro Ghizzardi, born on July 20, 1906 in Corte Pavesina, now lives in Boreto.

There is no doubt that Italy, which has produced more painters than any other country also leads in the field of naive painting.

Like other naives Ghizzardi sees reality through the inner eye of the soul as a kind of hallucination; he frees himself from this hallucination through the act of painting. Ligabue, the most famous painter of this kind, identified himself with the animals he painted, somewhat like the Shamans of Siberia. Ghizzardi's paintings of big-breasted women doubtless satisfy an obsession he has in this direction. There is a certain connection with 'art brut', but the difference between Ghizzardi and 'art brut' painters lies in the fact that Ghizzardi's pictures are still art, while the works of 'art brut' hardly fulfil this requirement any more.

Pietro Ghizzardi
Self Portrait, **1970**

Lorenzo Prato was born on April 28, 1911 in Villar Perosa near Turin.

In 1963, after travelling extensively in Africa, Indonesia, and England, Prato returned home to Italy. He began to ponder the reasons behind his leaving Italy, what he had left behind and what he had missed most during his long absence. It was nothing external, but the intangible substance of his native Piedmont. Perhaps this explains the density of his painting and intensity of feeling which exudes from his pictures.

His exhibitions in Italy attracted more and more people, provoking a spirit of competition amongst his fellow citizens, which led to a flowering of new talent. People suddenly began to discover the beauty of their surroundings. Such enthusiasm, of course, could only be fired by a person of genuine talent. Lorenzo Prato certainly possesses such talent.

Lorenzo Prato
Rural Scene

Aldo Verzelloni
Riders

Aldo Verzelloni was born in 1933 in Reggio-Emilia.

Verzelloni's pictures hardly seem remarkable, except for the rather specific, luminous quality of their blue, which is reminiscent of the grottoes of Capri. Add to this the fact that Verzelloni works for the Municipal Refuse Department, and one is again reminded how startlingly unlike each other naive painters are. Clearly naive painting can flourish at any social level, in elegant apartments as well as seedy suburbs. What naive painters have in common is a yearning for a world different from the one they have to live in. Perhaps the refuse worker Verzelloni loves such luminous blues and deserted landscapes, because they represent the opposite to dirty, overflowing rubbish tips.

His pictures also have a certain surrealistic quality, especially his stark landscapes, which seem to extend into infinity, like those by Tanguy and Salvador Dali. His tiny figures dotted around his landscapes like little toy men, also echo Tanguy, a painter totally unknown to Verzelloni.

Shalom de Safed, real name Shalom Moskovitz, was born in 1892 in Russia.

Safed is the name of a small village in Galilee well known in former times for its esoteric doctrines and sects. Shalom lives in Safed, where up to quite recently he worked as a watchmaker. Like many naive painters, he came to painting late in life and by accident, when he set about teaching his grandchildren the Bible. Thus his paintings have a mainly narrative content. They are free of all ornament and embellishment. Form and content combine the moment the picture detaches itself from the word and becomes an independent symbol. From then on the story refrains from using hieroglyphics and becomes purely pictographic, reminiscent of ancient Assyria, when the Babylonians started to show hunting and battle scenes in their pictures — a little like Shalom. His paintings are also not unlike Coptic and Ethiopian pictures, which both developed against a pre-Christian, Mesopotamian background.

Shalom de Safed
Stories from the Bible; Moses Preparing the Feast of the Passover

101

Menachem Messinger
The Lion of Judah

Menachem Messinger, born in 1898 near Semonsk (Poland), now lives in Israel.

Messinger is the son of a 'Shamash' of the native synagogue; when still very young, he showed an undeniable sculptural talent, which initially confined itself to carving walking sticks.

Messinger has many talents: he plays the violin, writes Yiddish and takes part in the Jewish village theatre.

He emigrated to Palestine in 1932, but only started to paint at 70. He undoubtedly belongs with such painters as Soutine,

Krémegne and Kokoine, who carried on the same tenacious struggle to tame and finally spiritualize the intractable substance of their material.

Messinger does not have the knowledge or education of these other painters, but this only increases the spontaneous charm of his landscapes. He paints the kind of animals one often finds in holy books, lions and other symbolic creatures. They all have a strongly heraldic quality and by and large their pictorial effect remains ornamental.

José de Freitas was born on December 14, 1935 in Vitória de Santo Antão, Pernambuco (Brazil).

José was a well known classical actor, but he left the stage in order to paint. One asks oneself what was the reason behind this move. He probably felt a compulsion and a need to give expression to his inner world of shapes and forms.

José makes use of strong colours and concentrates on scenes from the daily life of Brazil, teaming with people and where the sun is always high in the sky. One feels an evocation of the theatre and 'Carnival in Rio'. But his pictures do not quite reach the level of folklore, just as his religious pictures, with their touches of humour are not entirely in harmony with orthodox thought. The fact is that a naive painter knows of no law but that of compulsion, which forces him to express whatever lies on his heart.

José de Freitas
David and Bathsheba

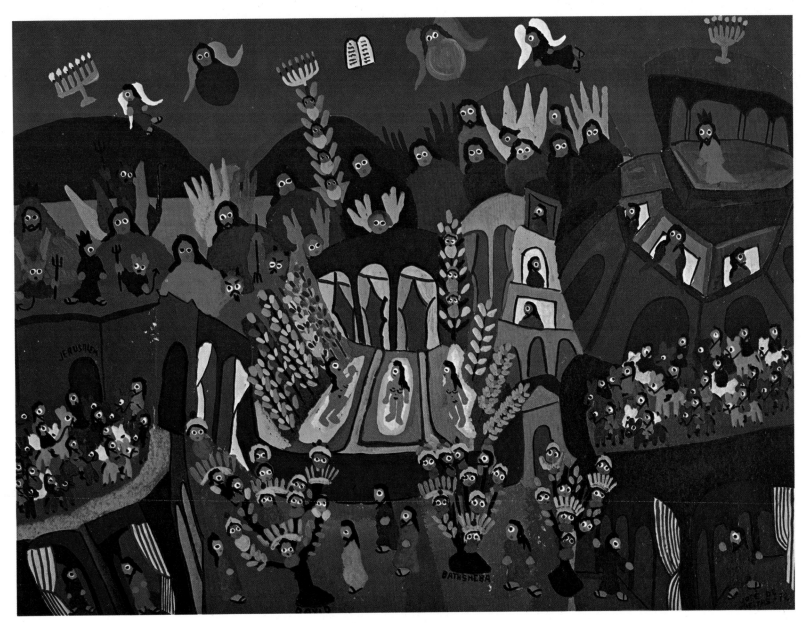

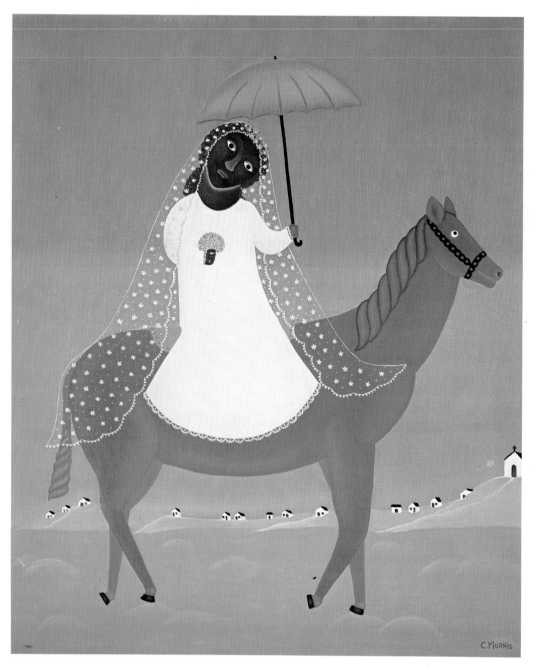

Crisaldo d'Assunção Morais was born in 1932 in Recife, Pernambuco (Brazil).

The flowering of painting in a given country is usually followed by the emergence of not one painter only but several. They come from everywhere and meet at a place as if by agreement, for instance in the Place de la République in São Paulo. Dozens of painters, men and women, came together there to sell their pictures to any casual passer-by — initially for almost nothing.

One painter, however, stood out from the rest. This was C. Morais, who did not restrict himself to the representation of the merely picturesque, or the exotic plant world — beautiful as this may be — but who succeeded in creating new symbols and in bringing the spiritual contents of reality on to the canvas. He has the capacity to capture his deepest emotions and reflexes and to give the beliefs, thoughts and legends of his people visible form. He does this by using archetypes barely visible under the thin layer of European culture but which are part of a rich Indo-American tradition, reaching back as far as Columbus.

Morais is the greatest, most original and profound Brazilian naive artist. He is a true 'painter', in the accepted sense of that word.

Crisaldo d'Assunção Morais
Woman on Horseback